INTRODUCING PHOTOGRAMS

# INTRODUCING PHOTOGRAMS

PIERRE BRUANDET

B T Batsford Limited

Copyright © Pierre Bruandet 1973
First published 1973
ISBN 0 7134 2322 6

Filmset by Servis Filmsetting Limited, Manchester
Printed by The Anchor Press Limited, Tiptree, Essex
for the publishers
B T Batsford Limited
4 Fitzhardinge Street, London W1H 0AH

# CONTENTS

ACKNOWLEDGMENT

The text was translated by Rodney J. Cox
and adapted by John M. Pickering

# WHAT IS A PHOTOGRAM?

A photogram is a photographic image obtained without using a camera. It is produced simply by the action of light on a light sensitive surface.

Natural surfaces are often sensitive to light. For example, apple peel or human skin turn red or become pigmented when exposed to strong sunlight.

The labels which are stuck on fruit and the straps of bathing costumes form a screen between the sun and the light sensitive surfaces and prevent them from turning red.

The image on a background obtained in this way is a photogram.

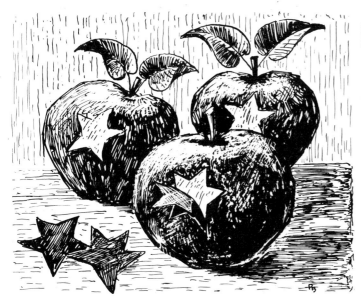

The light sensitive surface can also be an artificial one. This process exploits the fact that certain metallic salts change colour under the effect of light.

The most widely used of light sensitive compounds are silver salts. Black and white photography is based on their use.

Some papers used in certain kinds of photocopiers are sensitive to artificial light. The surface is made by covering the paper with a layer of emulsion based on silver salts. When the paper is exposed to light it can be seen turning progressively from white to grey. If an opaque object is placed between the paper and the light source, this object will have exactly the same effect as the bathing costume straps did on the skin: it will screen the light and prevent the paper from changing colour wherever it casts its shadow. The outline of the scissors which appear in white against a grey background is a photogram.

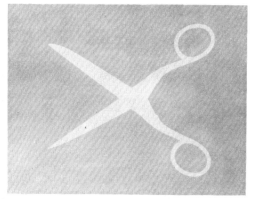

But it will soon become evident that the image obtained in this way is not permanent. As soon as the object which acted as a screen has been removed the light will affect the surface and gradually the image of the scissors will fade away into a uniform grey.

When photography was invented, one of the first problems that had to be solved was how to make a photographic image permanent.

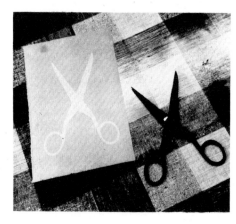

To do this it is only necessary to get rid of the silver salts unaffected by the light before they can turn black. This can be done by using hyposulphite of soda which dissolves unoxidized silver salts. The photogram has only to be immersed in this solution to prevent it from changing. After a short while, say 5 to 10 minutes, all the unoxidized salts are eliminated and the image obtained can no longer react to light. It is now *fixed.* Sodium thiosulphate is known as a *fixer.*

After fixing, the paper is rinsed in running water to get rid of any surplus chemicals and then left to dry.

Many light sensitive papers can be used, for example ozalid paper used by architects, but these have to be exposed to a very intense light (sunlight or ultra violet light) and have to be fixed with ammonia.

The results obtained by this method of exposure to light and of fixing are mediocre: the images are grey-brown or pale blue and lack contrast.

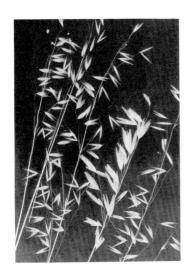
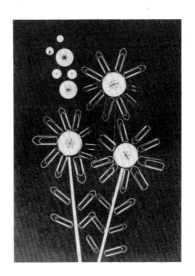
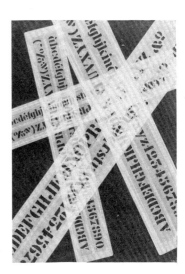

To obtain images with strong contrasts of black and white, substances which reinforce the action of light on the silver salts must be used. Such substances are called developers. They are called developers rather than reinforcers because they are so effective that only the slightest exposure to light is needed to change the silver salts, and this change only becomes visible after they have been immersed in a bath of developer. Before the paper enters the developer it appears blank, the image is latent. While it is in the developer the image can be seen emerging. When the contrasts on the photogram are adequate, the paper should be rinsed and then placed in the fixing bath (see illustrations).

If, however, it is not exposed to the light long enough, the image may lack contrast, the blacks and whites may appear as shades of grey. It is important therefore to determine the exposure time needed so that the image which appears in the developer will be made up of rich blacks, pure whites and greys.

The time of exposure depends on two factors:

1   The speed with which the light sensitive surface reacts.

2   The strength of the light source and its distance from the light sensitive surface.

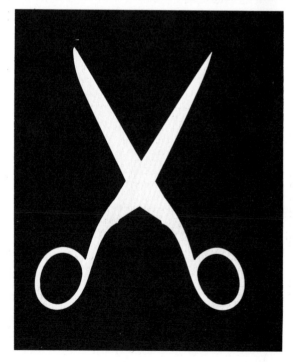

*Under exposed*

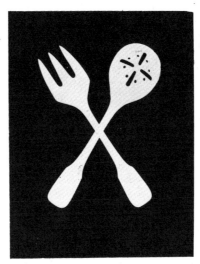

*Correct exposure*

*Over exposed*

## The speed of light sensitive surfaces

As people's skins vary as to how quickly they react to the sun, so there are some light sensitive papers which are affected by the smallest ray of light and others which have to be exposed for a longer time. True photographic papers which react quickly can only be used in a dark-room lit by a red or lime green light. Those who do not have dark-room facilities should use a different kind of paper.

Papers used in photocopiers are much slower to react and can be used for photograms by everyone. They are fast enough to react to exposure times of one to three minutes and slow enough to be handled in a slightly darkened room. Satisfactory results can be obtained in a classroom with drawn curtains.

Only one precaution is necessary: that is to keep the light sensitive paper inside a black paper container or in a box, and to take out only one sheet at a time.

Agfa papers made for the 'Rapidoprint' (Agfa-Gevaert) photocopying process were used to produce the illustrations in this book, but many other photocopying papers made by other manufacturers are quite suitable. Kodak projection paper P153 and Kodak Contact Paper C145 can also be used in normal room lighting – tungsten artificial or subdued daylight away from the window. The most suitable of the 'Rapidoprint' (Agfa-Gevaert) papers for this work are:

FCS 1 Grade 2
FCN 1 Grade 3
FCH 1 Grade 4

(all should be single weight, glossy).

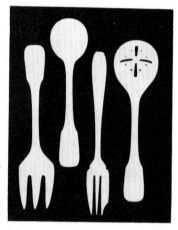

*With a clear bulb*

## Power and distance of light source

An ordinary clear glass 100 watt bulb placed 1·5 to 2 m (5 to 6½ ft) from the light sensitive surface is ideal for this type of work.

A clear bulb is used rather than a pearl one because it has a filament which incandesces. This filament is made up of an infinite number of luminous points which send their rays in a straight line through the clear glass of the bulb without any diffusion.

With a pearl bulb the rays of light are diffused all over the room and are reflected by the walls; the edges of shadows cast are not so dark and this causes a grey halo around the outline of a silhouette. Lighting with a clear bulb can be improved by fitting a black lampshade, which eliminates interference from rays of light reflected by the ceiling.

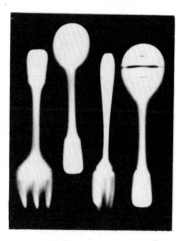

*With a pearl bulb*

The distance of 1·5 to 2 m (5 to 6½ ft) has been fixed as a result of practical experience. It will give sharp results with objects about 150 mm (6 in.) thick.

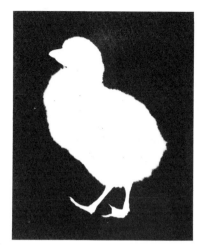

*Light source at 0·60 m (2 ft)*

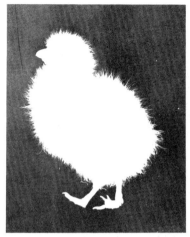

*Light source at 2 m (6½ ft)*

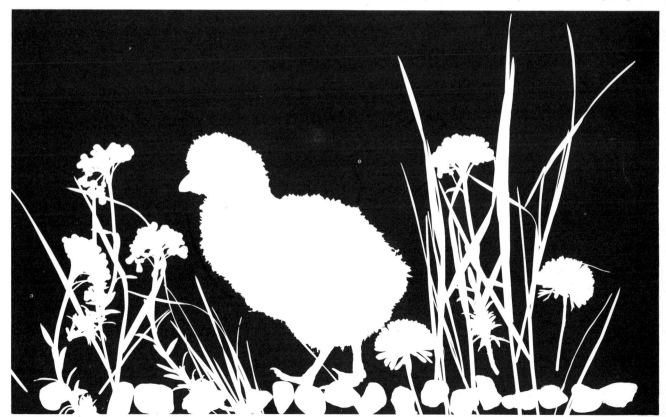

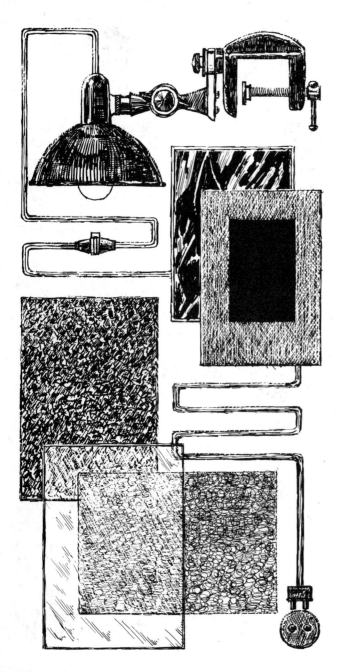

## Materials

The following materials constitute the basic requirements needed to produce a photogram.

A clear glass 100 watt bulb

A lampshade or a black reflector should be fixed to the bulb socket and about 5 m (16½ ft) of flex with a push button switch 2 m (6½ ft) from the light.

Light sensitive paper

Initially it is better to use only thin matt paper which will require a 1 to 3 minute exposure, for example, Agfa Gevaert Rapidoprint contact paper FC. Kodak projection paper P153 needs 1 to 10 seconds using a projector lamp 500 watt mains voltage, or 150 watt 24 volt tungsten-halogen lamp.

Photographic developer

Any concentrated developer can be used; Kodak Universal Developer produces good results. Instructions for the preparation, which is extremely simple, will be on the product.

Photographic fixer for paper

Most concentrated commercial fixers are suitable, for example Acid Hypo' Kodafix Solution diluted with 3 parts water.

Fix at a temperature of about 20°C (68°F) for about 1 minute.

To complete the equipment the following items are useful.

One piece of board, soft board or block board 12 mm ($\frac{1}{2}$ in.) thick measuring 240 × 300 mm (10 in. × 12 in.).

One sheet of polythene (polyethylene) 3 to 5 mm thick and 240 × 300 mm (10 in. × 12 in.) in size. (This can be bought at most large departmental stores.)

A pane of glass 6 mm ($\frac{1}{4}$ in.) thick and 240 × 300 mm (10 in. × 12 in.) in size. The edges should be polished to avoid the danger of cutting oneself.

3 plastic dishes for developer, wash and fixer.

2 pairs of plastic tongs to handle papers in the developer, wash and fixer.

2 1 litre (1$\frac{3}{4}$ pints) flasks for preparing developer and fixer and for keeping them afterwards. (These containers should be glass or opaque plastic.)

Slide projector.

Drawing pins or paper holder.

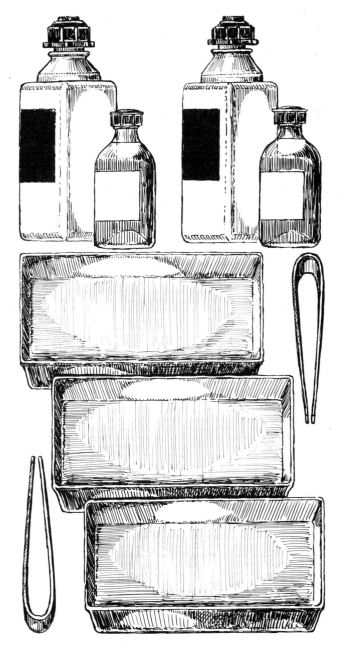

## Arrangement of the equipment in a classroom

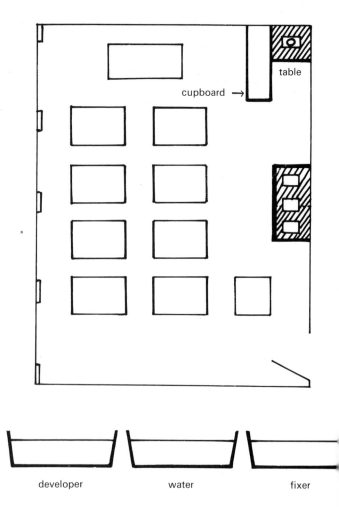

table

cupboard →

developer  water  fixer

### DURING DAYLIGHT

The room should be darkened by drawing the curtains.

*Exposure equipment*
Create an area in the room; for example place a table against the wall furthest away from the window. A tall cupboard placed next to the table so that it casts a shadow over the surface of the table is useful.

Fix a light at the required height above the centre of the table. Arrange the block board to support the piece of polythene and the piece of glass. Put the packet of light sensitive paper in a drawer in the table.

*Developing equipment*
Set out the three dishes on a table placed against the wall furthest from the window (see diagram). Arrange them in the following order from left to right: developer—water—fixer. A large bucket of water should be available under the table for rinsing the prints after fixing.

### EVENING OR SEMI DARK CONDITIONS

The same system can be adopted. The room should be lit by incandescent lighting. Fluorescent tube lighting is not suitable but the more outdated pearl light globe used in older school classrooms can be used.

Switch on only the light furthest away from the exposure table and the developing equipment.

Before moving on to the various exercises several explanations as to the whys and wherefores of this activity and brief consideration of its educational implications are necessary.

# THE USES OF PHOTOGRAMS

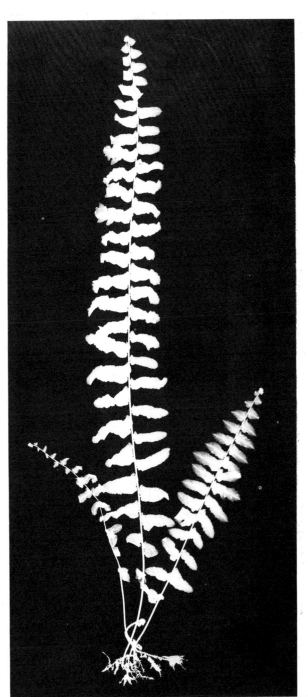

1   They involve an approach which allows the basic principles of photography to be understood and assimilated in a concrete way.

2   They are a means of learning and applying the rules of graphic composition without the need to draw.

3   They are a means of becoming involved in a form of artistic creation that is not expensive and well within the reach of most people. It requires little equipment and the cost of a single photogram of 210 mm × 270 mm ($8\frac{1}{4}$ in. × $10\frac{1}{2}$ in.) is only a few pence.

4   They have a wide variety of uses including collage, decorative motifs for such things as: boxes, caskets, waste paper baskets, lampshades, mobiles, decorative panels and greeting cards.

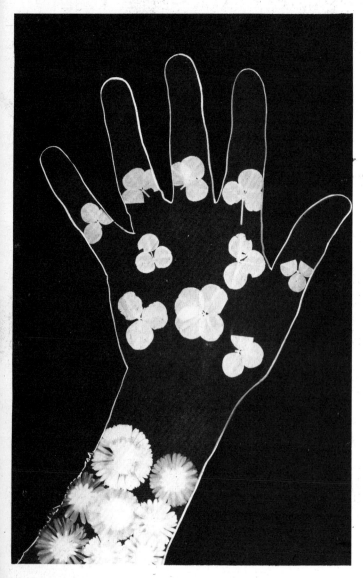

The photogram can also be used in designing posters or illustrations for reproduction.

It can also be used as a method of photocopying directly from documents and illustrations.

The following exercises are arranged in a progressive order of complexity to help the reader to come to terms gradually with the various techniques. They by no means suggest all the possible methods and with imagination many other ways of producing photograms and creating new and exciting images can be discovered. The greatest merit of the photogram is its simplicity and flexibility.

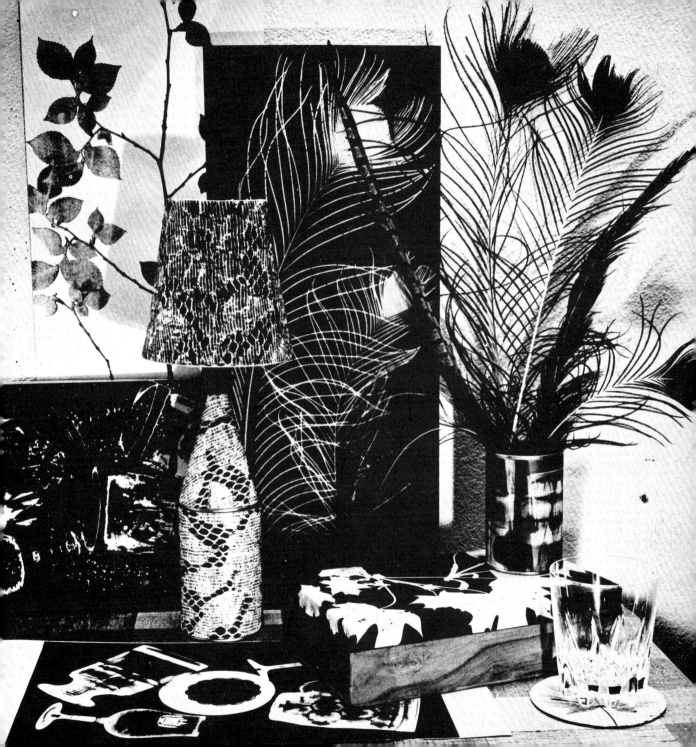

## The equipment

### Light sensitive paper

Only one side of the paper is coated with light sensitive emulsion. With experience this surface will be easily recognised.

### Developer

Dilute the concentrated solution according to the manufacturer's instructions and pour about 1 litre (1¾ pints) of the solution into the first dish. (Kodak Universal Developer is diluted 1 part developer with 7 parts water).

### Rinser

Pour clean cold water into the second dish.

### Fixing bath

Dilute the solution according to the manufacturer's instructions. Pour 1 litre (1¾ pints) into the third dish. (Kodafix Solution 1 part diluted with 7 parts water).

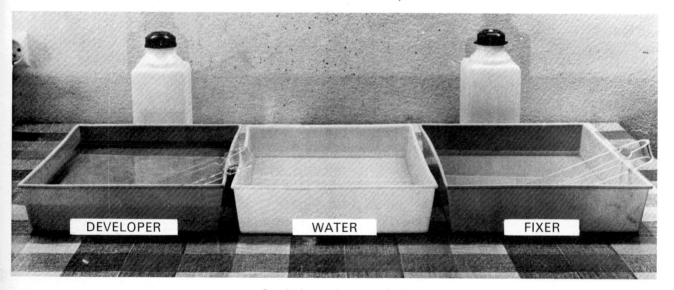

DEVELOPER    WATER    FIXER

*Developing equipment ready for use*

## Exercise 1

How to determine the right exposure time.

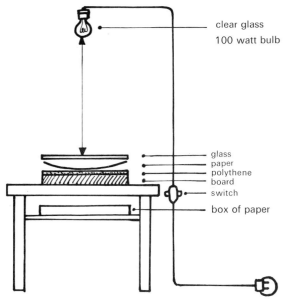

clear glass
100 watt bulb

glass
paper
polythene
board
switch
box of paper

Place a piece of cardboard on top of the glass leaving only one quarter of the sensitive paper exposed.

Exposure:
Switch on the light for 30 seconds.
Move the card to expose half the paper. Switch on for 15 seconds.
Uncover three quarters of the paper. Switch on for 20 seconds.
Remove the card and expose all the paper for 30 seconds.

Developing:
This depends on the kind of developer used but normally takes one to three minutes. Try to obtain maximum contrast with pure whites and dense rich blacks.

After the first experiment it will be found that an average exposure time of 90 seconds with the light source 2 m (6½ ft) from the paper can be used as a basis.

Rinsing:
Rinse the paper in clean water in the second dish.

Fixing:
Slide the paper into the third dish and leave it, rocking the dish occasionally, for 5 minutes. (If Kodafix Solution is used 1 minute at 20°C (68°F) is adequate).

Final wash:
Wash the paper for two hours in a sink, using running water if possible.

*Note*   This process is repeated in exactly the same way in the following exercises, except where special effects are required.

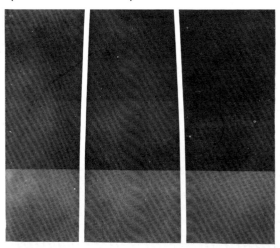

## Exercise 2

The simplest photograms are created with rigid opaque objects such as the scissors in the illustration.

Place the scissors on the glass.

Exposure: Switch on the light for 90 seconds.

Follow the normal procedure of developing, rinsing, fixing and washing.

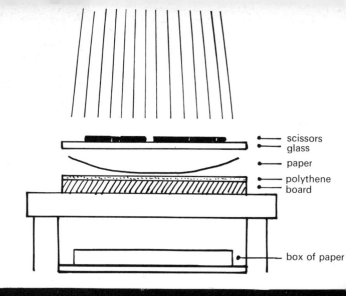

scissors
glass
paper
polythene
board
box of paper

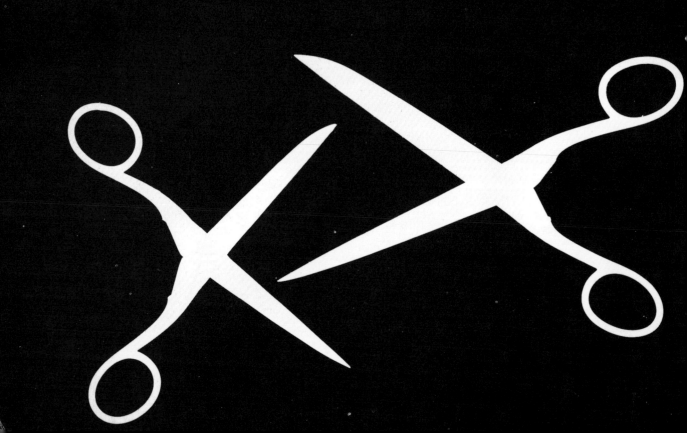

## Exercise 3

Photograms can also be created with a wide range of opaque objects which are thin and flexible, such as feathers. The feather should be placed beneath the glass in direct contact with the paper (see diagram).

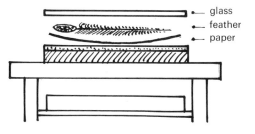

glass
feather
paper

Beautiful linear designs emerge from photograms of feathers. Peacocks' feathers are most suitable because of their structure and produce exciting designs.

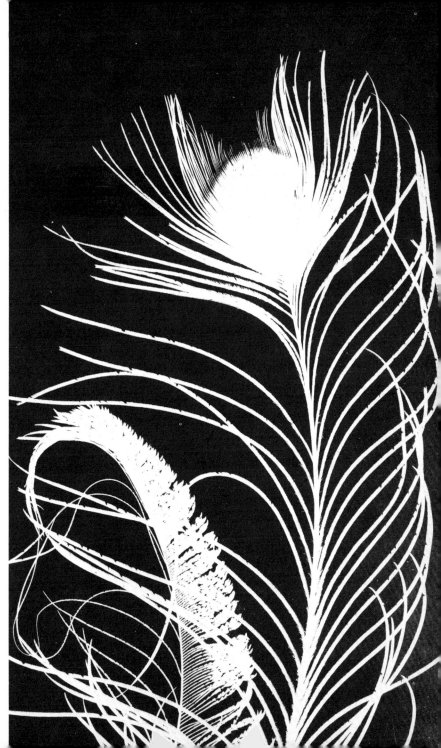

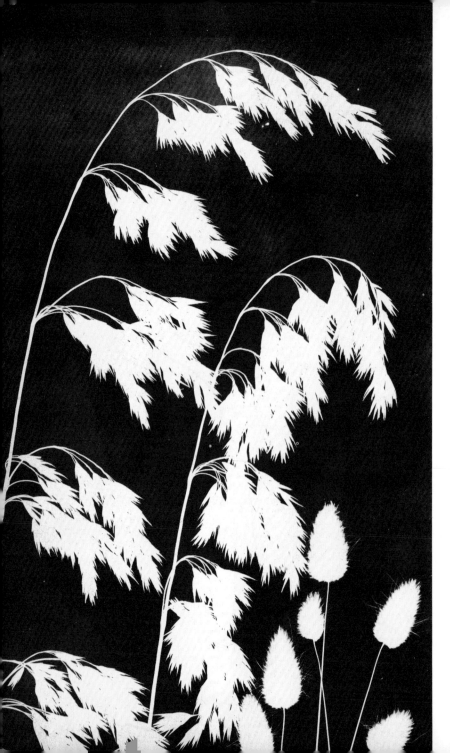

Exercise 4

Photogram with flexible objects of medium thickness.

Grasses have an excellent potential for this kind of work. Concentrate on the seeds heads and arrange them with care, although a chance arrangement can produce interesting results.

Proceed exactly as in exercise 3.

To retain the precise details of the grasses care should be taken with exposure times. If the exposure is too long the finer details tend to disappear.

## Exercise 5

Photogram with thick transparent objects such as cut glasses.

glasses

Place the glasses on top of the sheet of glass, although it is also possible to place the glasses directly upon the paper.

Exposure: 45 to 60 seconds.

The half tones produced by the facets of the glass create interesting patterns and textures.

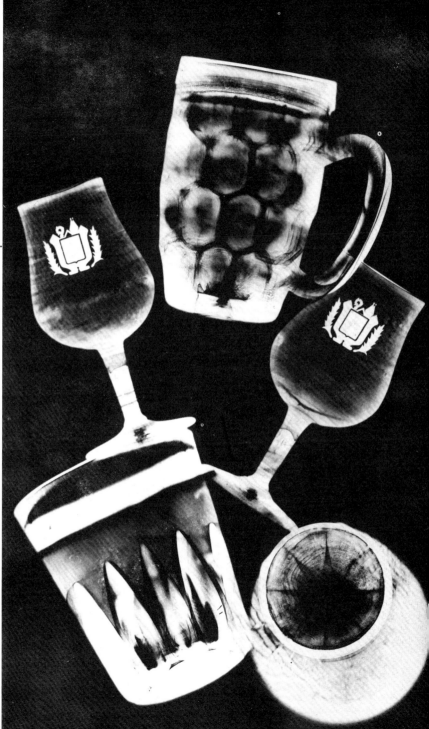

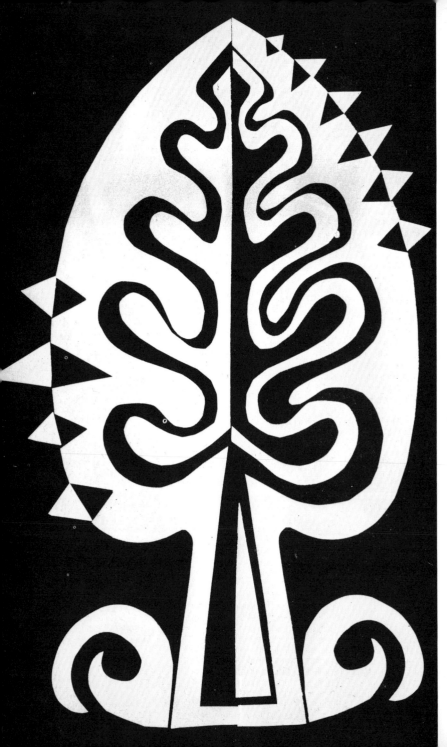

## Exercise 6

Photogram created by masking areas with cut paper.

Cut out various shapes from black paper, then place them beneath the sheet of glass as shown in the diagram.

The exposure should be the same as in exercise 2.

cut out
black paper

To ensure that a sharp image is obtained take care to make a good contact between the masking paper and the light sensitive paper. A blurred image indicates a poor contact.

## Exercise 7

Folded translucent paper such as tracing paper can produce a range of half tones according to the thicknesses of the folded paper.

Fold the sheet of paper in such a way as to have one, two, three or four thicknesses on top of each other. Lay the tracing paper beneath the glass sheet to ensure a good contact.

folded paper

The exposure time will vary according to how many thicknesses of paper are used, and will have to be determined by experiment.

27

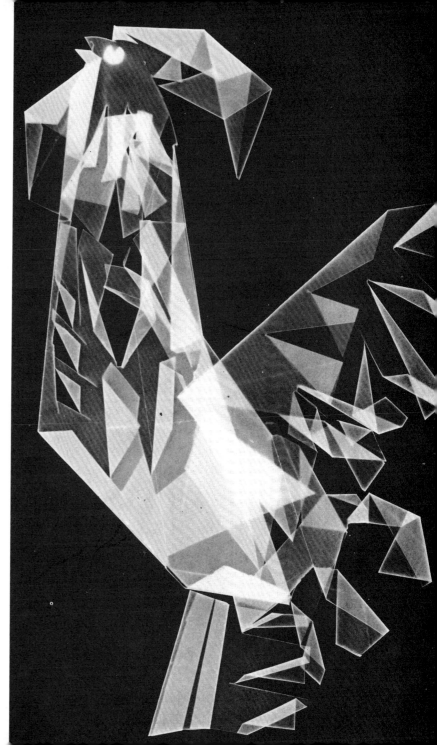

## Exercise 8

Fine textural effects can be made by using materials like sand, coarse grained salt or sugar. The photogram in this illustration was produced with carborundum powder.

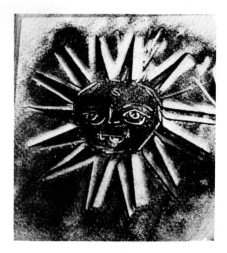

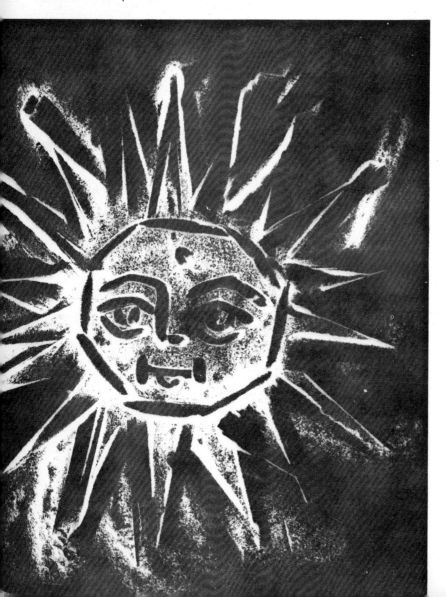

Preparation: Because of the danger of damage to equipment and materials through dust, it is important to prepare the sheet of glass on which the fine powdered material is to be laid away from the equipment area.

Spread a thin layer of the dust on the sheet of glass.

Using a finger, paint brush, piece of card or anything with a fine point or edge, trace in the required motif.

Exposure: Place the sheet of glass over the light sensitive paper and expose for 60 to 90 seconds.

Where the powder has been removed the paper will be black. Half tones will emerge in varying densities depending upon the proximity of the grains of powder.

## Exercise 9

Large objects can be used to produce photograms. Even a human head can be used providing the paper is large enough.

The distance of the light source from the light sensitive paper must be increased to about 3 m (10 ft).

Exposure: Lay the paper on the ground and use a normal light source in the ceiling. The person should keep very still as movement will create a blurred image during the exposure. Arrange the hair, avoiding dense masses, to produce a fine textural effect rather than large white areas.

The exposure time can be reduced by using a slide projector as a light source. A further advantage is that the light can be in focus and a better defined image is possible. The calculation of the exposure time is a matter of experience, and a trial and error approach will have to be adopted at first.

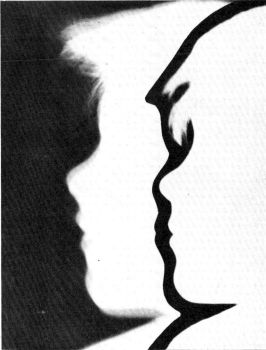

## Exercise 10

Photograms with printed matter.

Using transfer type lettering (Letraset) make up the text required on a sheet of cellophane away from the exposure equipment.

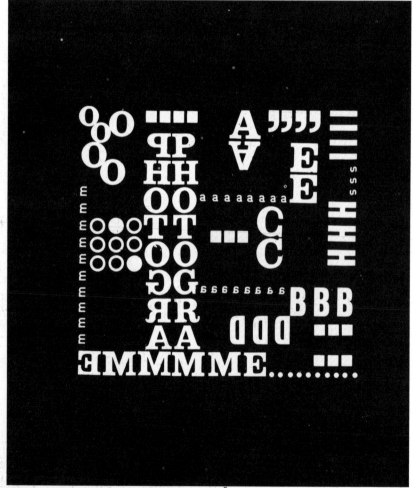

Exposure: Place the sheet of cellophane with the text on the light sensitive paper and put the sheet of glass on top as shown in the diagram. Expose for 60 to 90 seconds with the light at 1·5 m (5 ft).

The result will reveal white letters on a black background.

30

## Exercise 11

A photogram with decorative motif. This is an excellent way of producing greeting cards.

Lay the plant on the light sensitive paper and cover over with the sheet of glass.

In order to obtain clear definition when making photograms with dried plants good contact is essential. It is a good idea to make the plants pliable by soaking them in water and glycerine for half an hour before using them. The wet branch should be dried before being placed on the light sensitive paper.

Exposure: 60 to 90 seconds with the light source 2 m (6½ ft) away.

A mixture of half tones and solid whites and blacks should be obtained from the translucent and opaque parts of the objects used in this exercise.

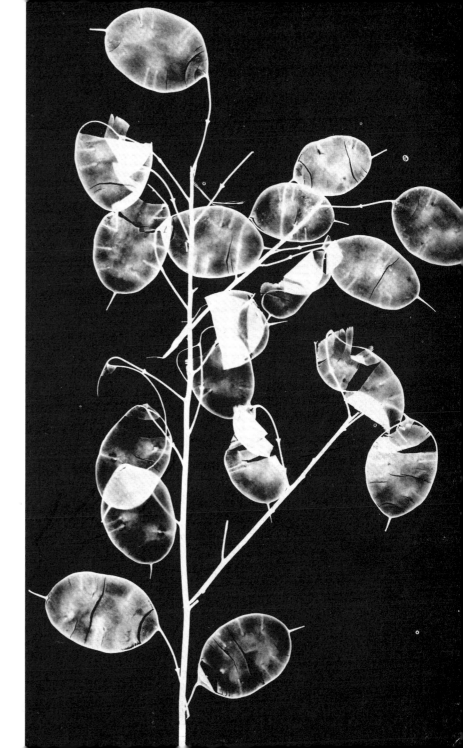

## Exercise 12

### Photocopying documents

In the ten previous exercises the light fell directly upon the light sensitive surface; in this exercise it acts by reflection. First the light passes through the light sensitive paper which has been placed with the emulsion side against the document. The white parts of the document (i.e. the background to the print) reflect the light which acts in the normal way upon the silver salts.

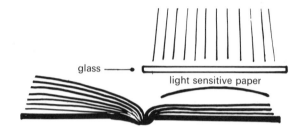

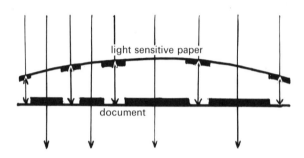

The darker areas or the black parts of the document absorb the rays of light and show up as grey or white on the light sensitive paper.

The image that appears in reverse is similar in other respects to the one in the previous exercise.

Exercise 13

Production of a positive print

Normally when photocopying a text the aim is to produce an image exactly the same as the original. Using a single sheet of paper in the previous exercise a negative was produced. If the negative is used as in the diagram, that is the light sensitive paper is placed emulsion side up and the negative is placed on the light sensitive paper image side down, a positive can be produced. The sheet of glass on top of the negative and paper creates a good contact which is essential in work of this kind.

face. The exposure time is much shorter than the previous one and has to be determined by experience. Again a perfect contact between paper and negative is important for a good print.

This method is very well known to photographers who refer to it as 'contact printing'.

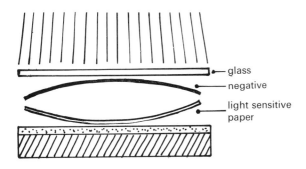

glass
negative
light sensitive paper

Exposure: This depends on the density of the negative and may be between 3 and 5 minutes. Developing and fixing are carried out in the normal way.

Using this method it is possible to print positives from normal photographic negatives.

Place the matt side of the negative in contact with the emulsion side of the light sensitive sur-

## Care with negatives

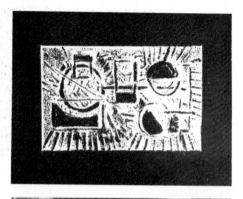

(a) Curling of the edges of a negative can be a problem as this tends to cause fogging or fuzzy edges to the print. A neutral strip 20 to 30 mm ($\frac{3}{4}$ in. to $1\frac{1}{4}$ in.) wide allowed around the edge of the negative should help to overcome this problem.

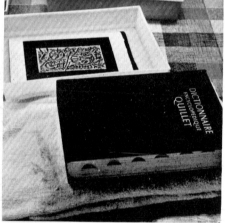

(b) Drying the negative is most important. One method is to place the negative between two pieces of well ironed absorbent material (old sheet for example). Place the whole thing on a level surface and put on top a weight, such as a board and heavy books. Move the material from time to time during drying, but be careful not to disturb the negative.

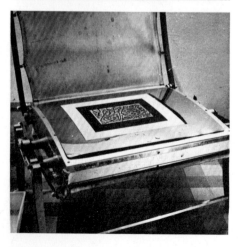

(c) Another method is to use a photographic glazer, putting the image in contact with the fabric canvas not the chrome plate. Remove the negative while it is still slightly damp and allow to dry out by itself.

## Additional measures that may be taken during exposure

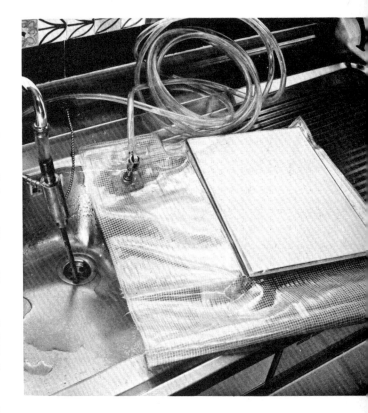

These require a certain amount of equipment: a vacuum bag made of transparent plastic and a vacuum pump.

Place the light sensitive paper and negative together in the way previously described but do not put the sheet of glass on top.

Place everything in the vacuum bag attached to the pump by a plastic tube.

Close the bag by folding over the top on itself twice.

Turn on the water tap. The vacuum pump removes the air from the bag and the pressure created pushes the light sensitive paper and negative hard against the support material which ensures excellent contact.

Normal exposure with the light 60 cm (2 ft) from the paper.

Switch the pump off by turning off the water, open the bag and take out the negative and paper which has been exposed.

Develop and fix.

# SPECIAL EFFECTS

## 1 DURING EXPOSURE

### Exercise 14  Moving the light source

This method produces interesting effects with transparent objects.

Place a drinking glass in the centre of a sheet of light sensitive paper. Move the light 4 times and expose for 13 seconds each time from each of the different positions, with the light 1 m ($3\frac{1}{4}$ ft) from the glass. Do not forget to switch the light off during the movement.

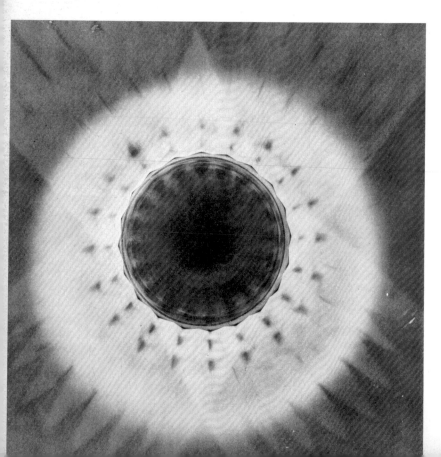

Another interesting effect is achieved by placing the exposure block on a small turntable (see diagram) and turning it about 30° between each exposure.

In this case a paper mask is required to mask off all but the shadow of the glass. Some care has to be exercised in positioning the glass.

The result obtained by the multiplication of the shadow can be very effective.

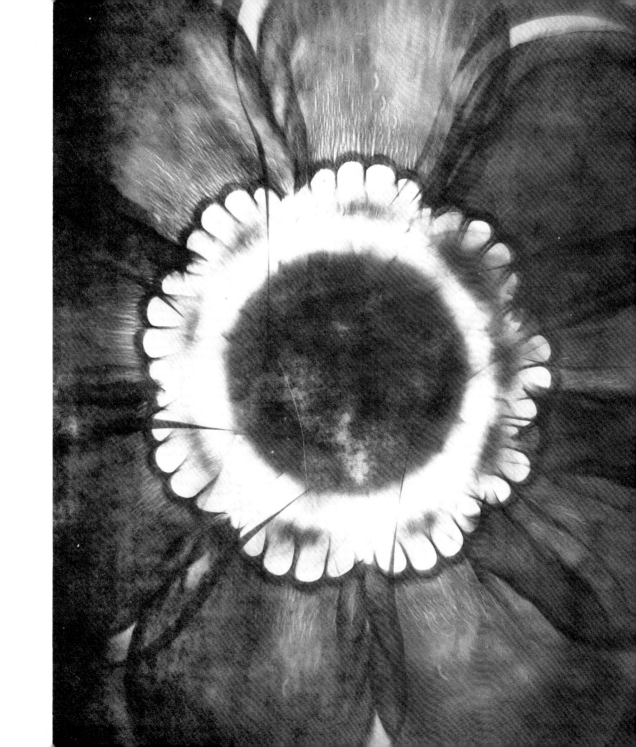

# Exercise 15

## Moving the object

As in the last exercise transparent objects can produce interesting effects.

Place a glass or several glasses on the sheet of glass.

Expose for 15 seconds then move the glasses and expose again for 15 seconds. Repeat the operation, but it is unwise to carry out more than four moves or the picture will be over exposed.

The best results are obtained when the images of the objects overlap.

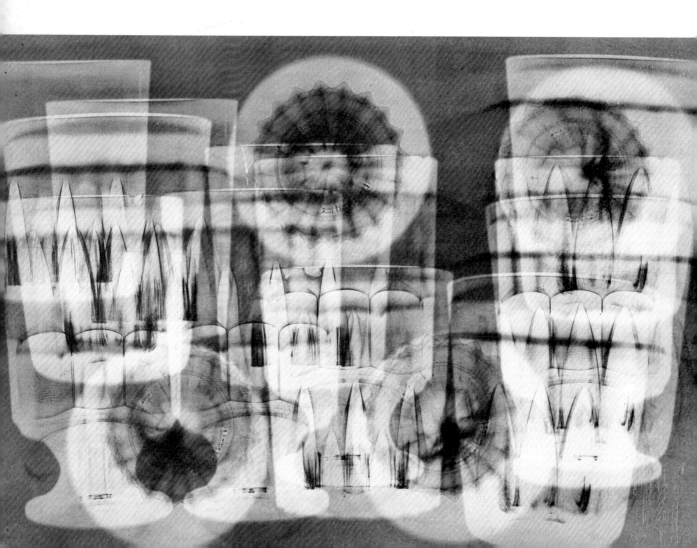

## Exercise 16

### Multiple light sources

This system enables a composite image to be produced without moving either the light or the object.

Place four lights in such a way as to create shadows falling within the format of the paper. Experiment on ordinary paper first before using the light sensitive kind.

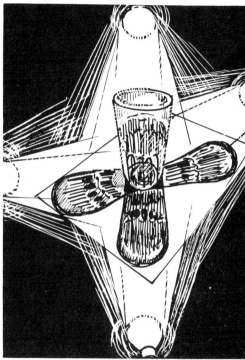

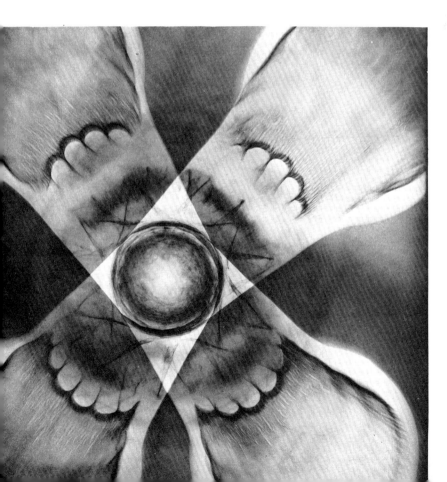

The exposure required varies with the power of the lights and their distance from the object, and is normally determined by experiment.

In the illustration four 100 watt lamps were placed at a distance of 1 m ($3\frac{1}{4}$ ft) from the object.

The exposure time was 15 seconds.

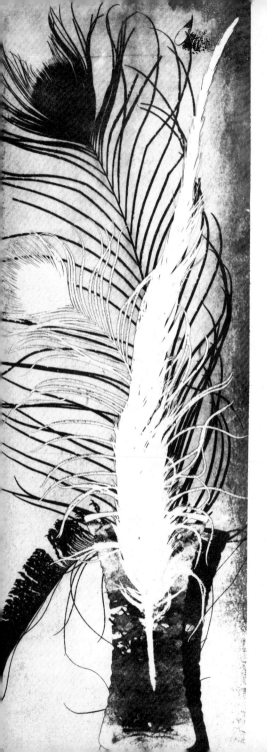

## 2 SOLARIZATION

Solarization is the exposing of a photogram to the light while it is being developed. Using this technique it is possible to achieve unusual and decorative effects.

### 1 To emphasize the detail

The object used in this photogram must be translucent and have areas of half tones, e.g. feathers, some kinds of leaves, etc.

Two methods can be used.

Exercise 17  *Method 1*

Expose for about 90 seconds.

Develop until the deepest black appears.

Solarization: Place the dish of developer and developing photogram under the light source and switch it on.

As soon as the details begin to appear switch off the light and continue developing until the desired effect is obtained. Rinse and fix in the normal way.

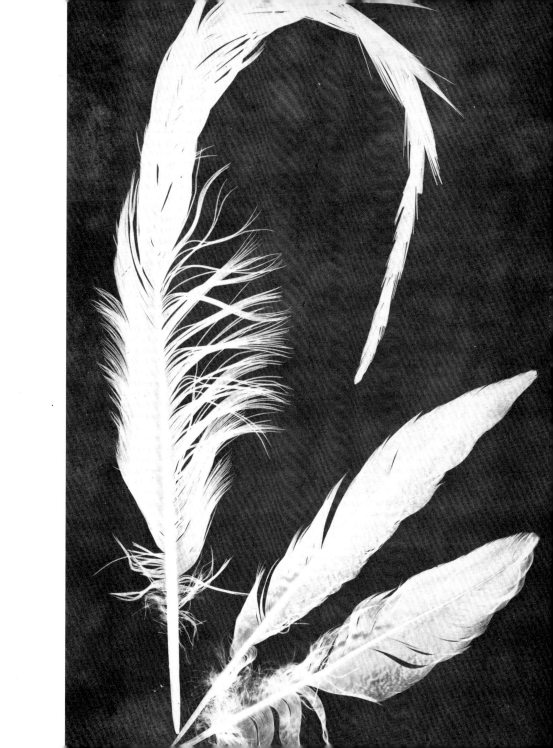

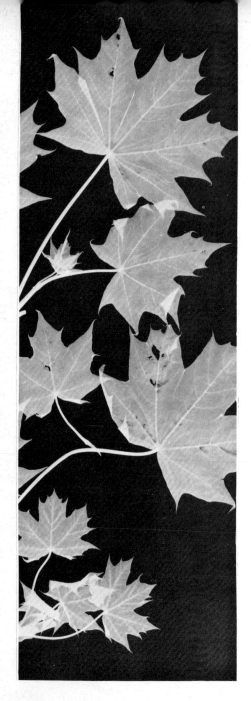

Exercise 18  *Method 2*

Expose and develop as in exercise 17.

Solarization: After the black has appeared, rinse the light sensitive paper and blot it.

Place it on the exposure block.

Switch on the light for 10 to 12 seconds; the exact time has to be determined by experience.

Re-develop the solarized photogram, rinse and fix.

Note: the first part of solarization can be replaced by a pre-illumination of the light sensitive paper before it is exposed.

The illumination time has to be determined by experiment. It is about 10 to 30 seconds. The aim of this operation is to transform a light sensitive paper which gives harsh contrasts into a paper which gives more subtle and gentler tonal relationships, revealing not only the half tones but the fine detail as well.

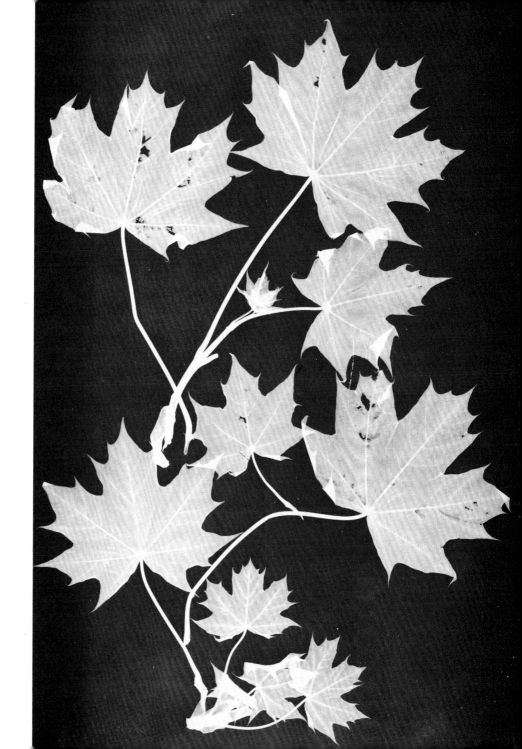

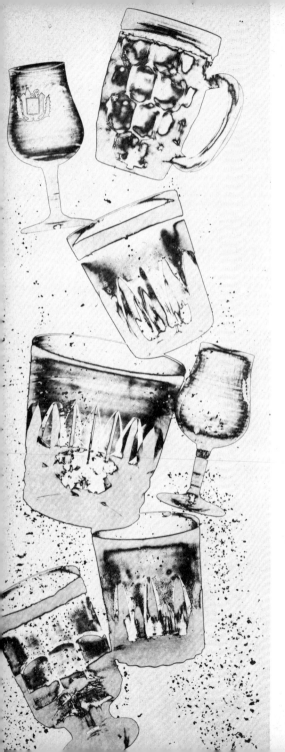

## 2 Decorative effects

The most interesting results are obtained with objects that are transparent or translucent. It is also possible to use objects with raised or rounded surfaces lit by several lights.

Exercise 19

Using cut glasses

Proceed as in exercise 5 for the first exposure.

Develop, rinse and dry. Then follow the same methods used in exercise 18 but set the light 1 m ($3\frac{1}{4}$ ft) from the exposure block.

Solarization: Solarize for 25 to 30 seconds until a slight violet tone begins to appear.

Develop until the correct tonal values appear, then rinse and fix.

Note: To master this rather difficult technique, one should slow down the action of the developer by diluting it with 50% more water.

The result is that the edges of the images have become fringed with white and that the greys also have become white.

Exercise 20

Contact prints and solarization

To get rid of the violet tones which appear during solarization contact prints may be made using the methods described in exercise 13.

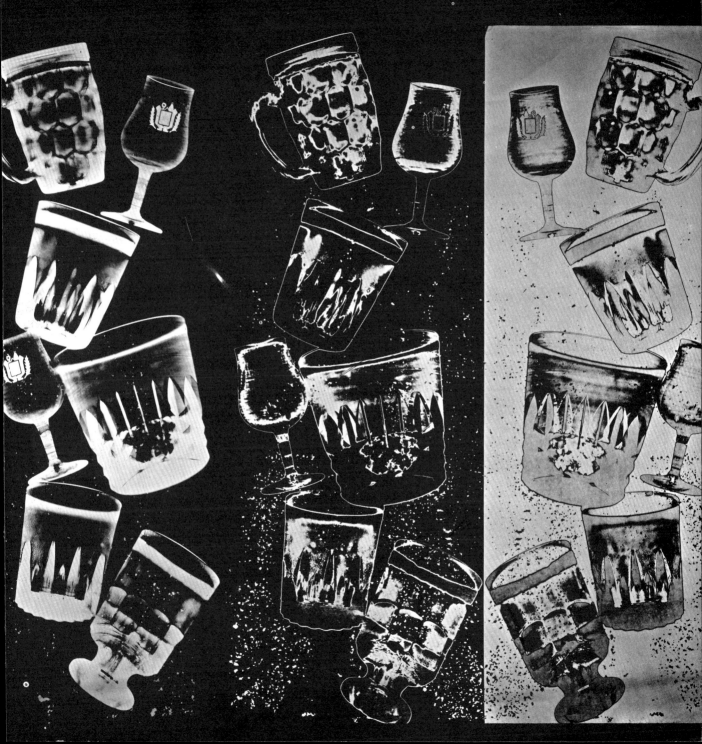

## 3 USING ONE IMAGE ON TOP OF ANOTHER

Exercise 21

The placing of one image on top of another image can only be achieved after the first one has been developed (see exercise 18).

The image which is already developed, rinsed and dried is placed under the sheet of glass and the objects are put on top.

The second exposure is now made for about 30 to 45 seconds. Develop and fix.

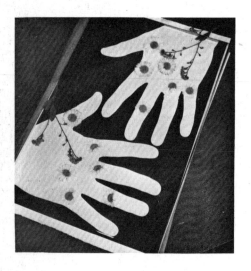

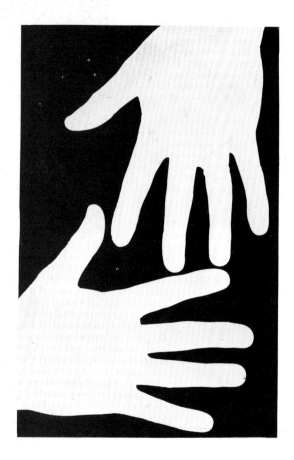

Certain precautions must be taken. The white parts of the first image turn grey. To keep the edges white and sharp in definition masking should be used during the second exposure. One way of doing this is to place some substance like sugar, salt or carborundum on top of the sheet of glass over areas that are to be protected.

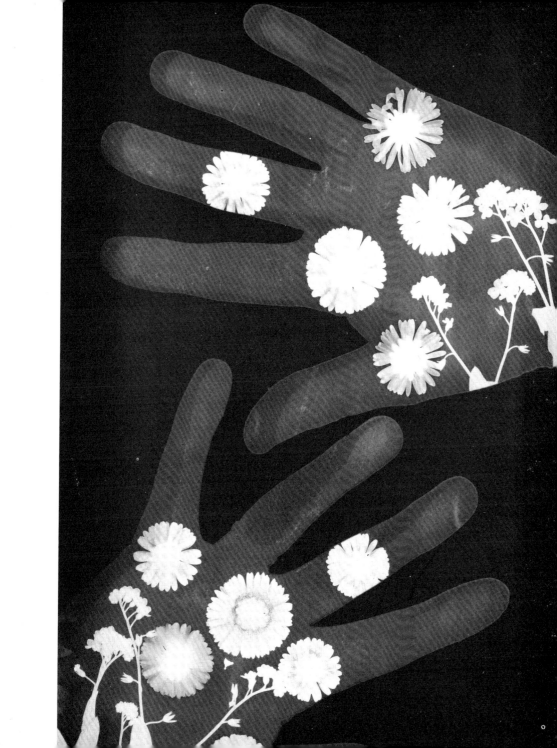

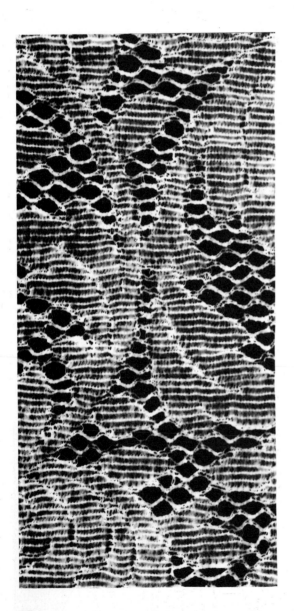

## EFFECTS PRODUCED BY
## USING VARIOUS SUBSTANCES

By using different substances it is possible to create visually stimulating textures and patterns: water, ink or coloured varnishes can be dropped on to the sheet of glass or concentrate solutions of sugar, salt, fixer, developer, etc can be crystallized on it by evaporation.

It is even possible to get a photogram of frost crystals deposited on a sheet of glass left out in the open on a cold winter's morning or during the night.

Effects obtained in this way can be considerably enhanced by solarization and by producing reversals through contact printing.

The following illustrations show the graphic possibilities of this procedure.

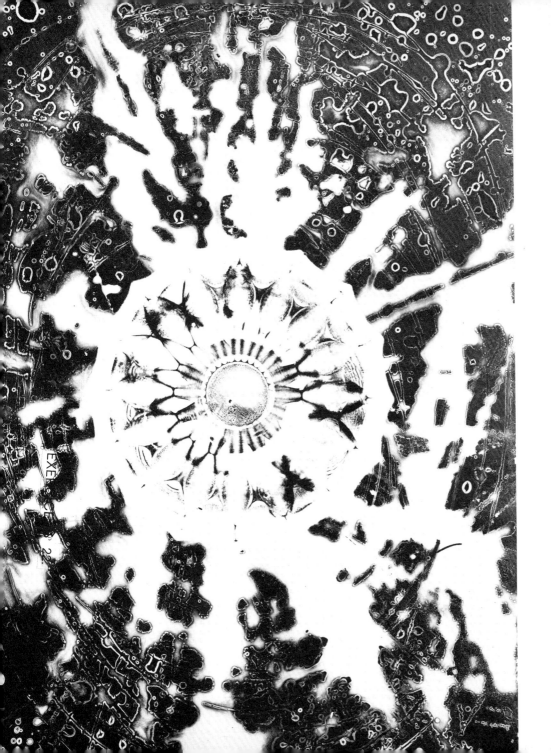

*Glass*
*Drops of water*
*Marking ink*

Exercise 23

*Flour poured through
a salad basket*

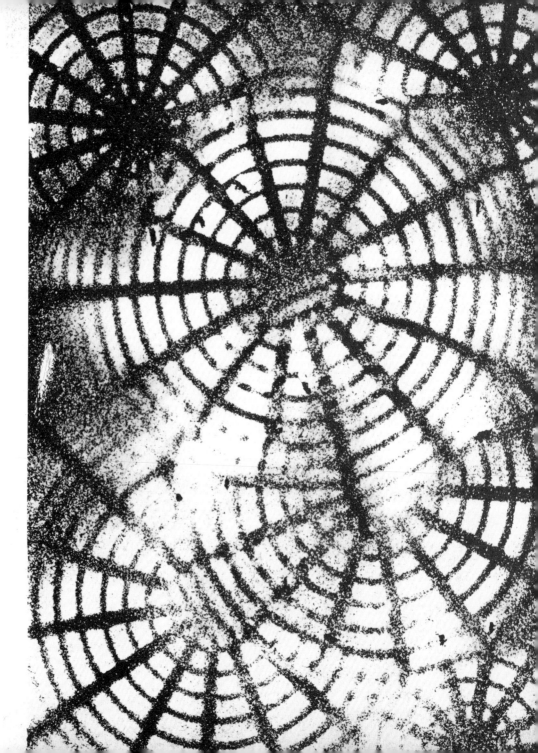

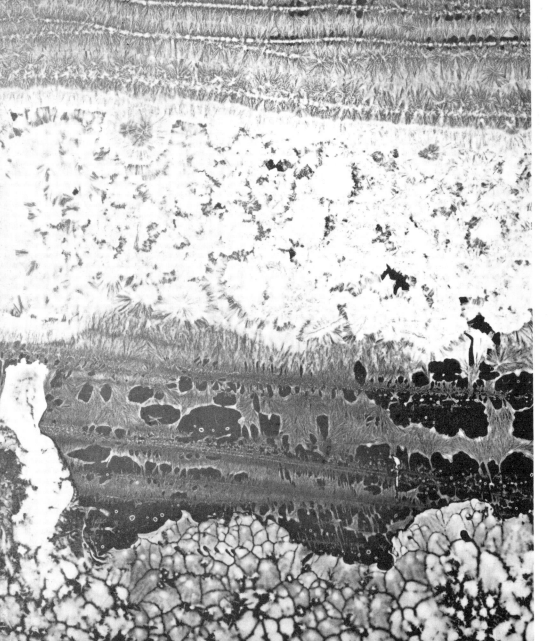

*Crystallization of fixer*

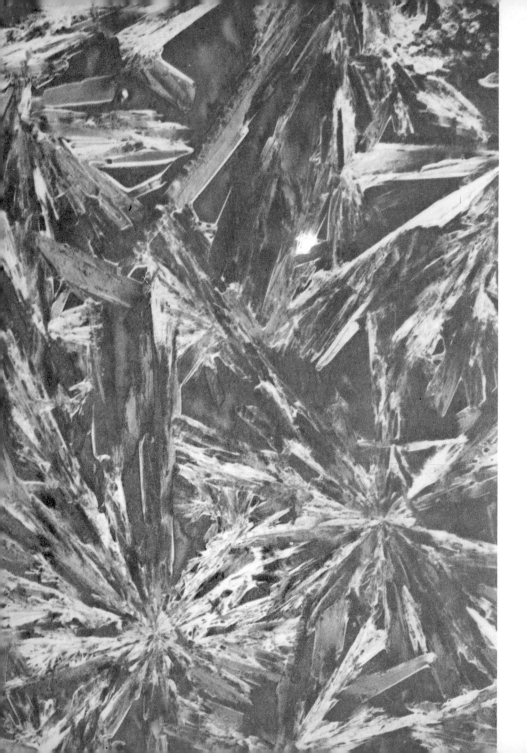

*Crystallization*

The substance selected was spread over a glass slide.
   After crystallization it was projected by a slide projector.
   To obtain greater contrast the lens was covered with black paper with an 8 mm ($\frac{1}{4}$ in.) diameter hole in it.
   Exposure time at a distance of 2·2 m (7$\frac{1}{4}$ ft): 3 minutes

Exercise 26

*Crystallization*
*Contact printing*
*positive—negative*

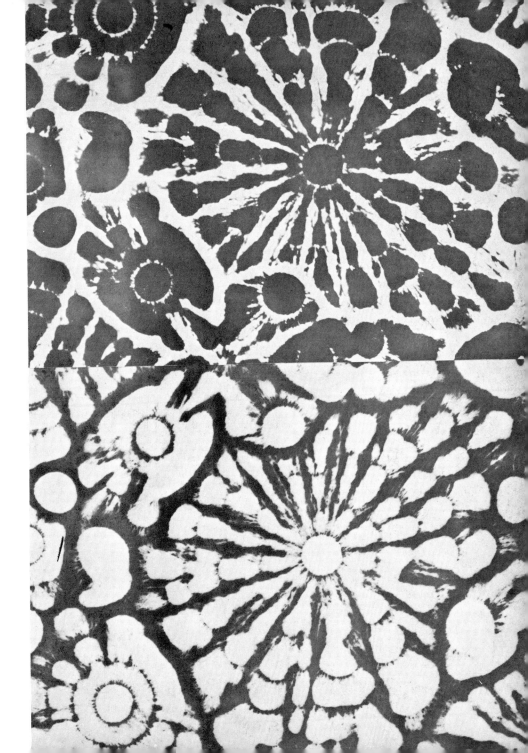

Exercise 27

*A menu cover based
on a piece of lace*

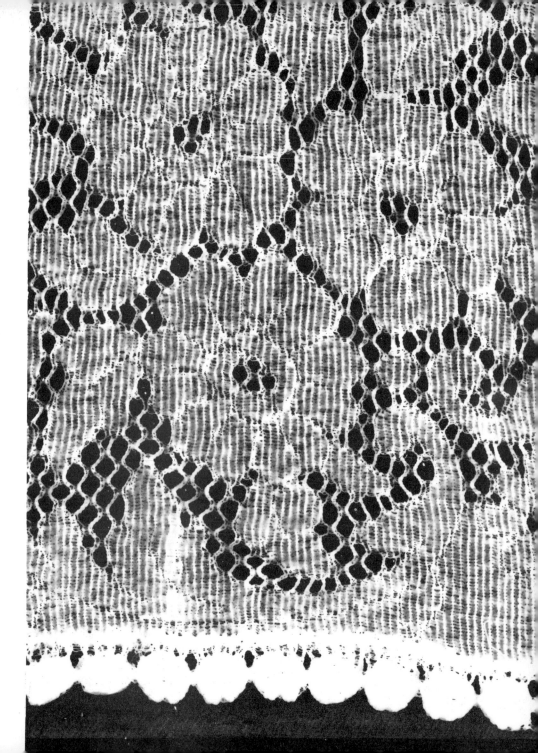

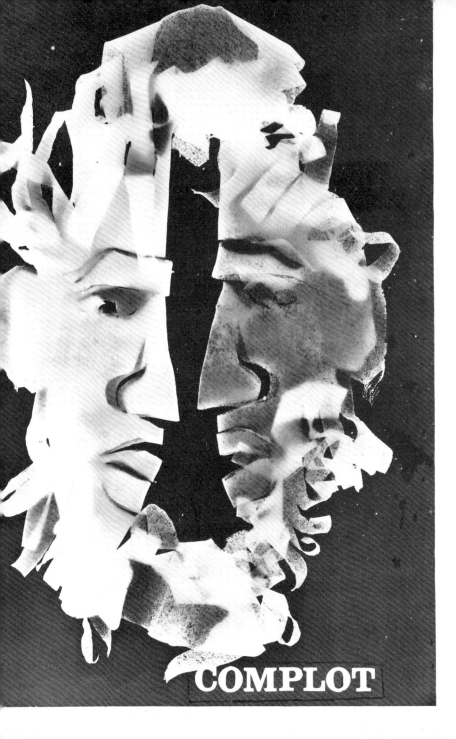

COMPLOT

Masks in plastic foam which has been folded and cut to produce this theatrical pub-lication

## 4 PARAGLYPHS

Paraglyphs are images produced by placing a positive slightly out of line over a negative (see diagram).

Use translucent light sensitive paper to make the preliminary proofs.

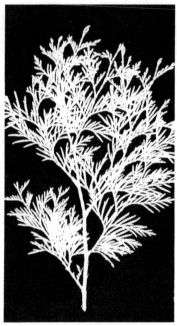

*Negative*                    *Positive*

Exercise 29

Paraglyph based on a branch from a conifer tree

The exposure time is quite long, 3 to 5 minutes, with the light at a distance of 60 cm (2 ft).

Place the positive and negative face to face. Check the positioning by holding them against the light and then fix them together with *Sellotape (Scotch Tape).*

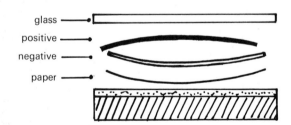

glass
positive
negative
paper

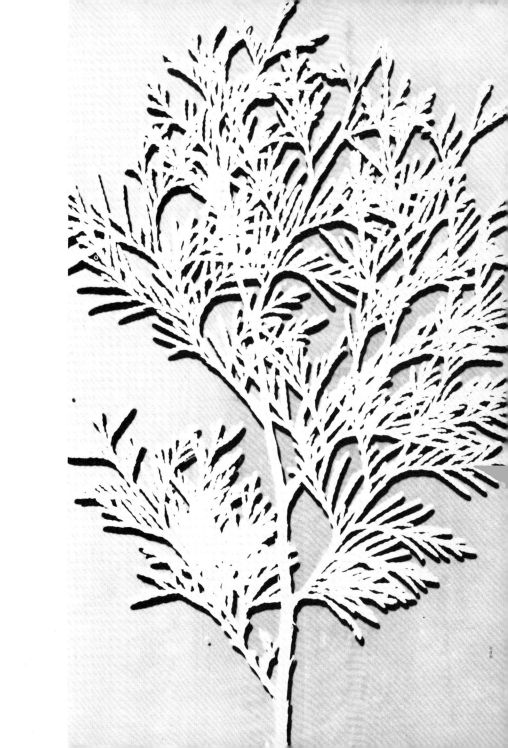

*A paraglyph*

# PHOTOGRAMS AS A MEANS OF EXPRESSION

*Photogram for a
cartoon illustration* ▶

Photograms can be used in poster designs and for illustrations for books.

The spatial aspects that occur in two dimensional work are easily obtained by using various thicknesses of translucent materials which give the tonal effects required perhaps in the background of an illustration. In the foreground opaque materials might be used.

Translucent materials such as tracing paper, creased cellophane, plastic foam are excellent for this method.

Figures or characters may be created from such materials as paper, insulated wire, string, tin foil, pipe cleaners, etc.

These can then be mounted with glue on the tracing paper.

Textures made from powder granules, seeds, or very small pebbles like those used in a fish tank, placed on glass, could be used to represent the ground.

If a text is required, Letraset type letters may be used, or letters can be drawn on translucent paper with indian ink or felt tip marking pens.

It is important to remember to invert the text on the original photogram if a positive is required.

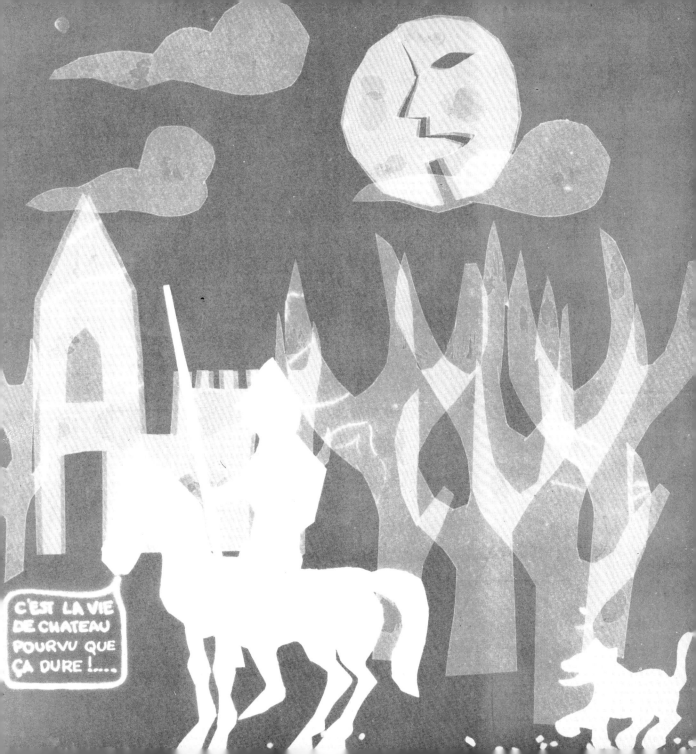

Exercise 31

**Composition with opaque objects.**

Place the various objects on a sheet of glass.

Put the glass on top of the light sensitive paper.

Expose and develop in the normal way.

*A train   parts of a constructional toy—paper clips—elastic*

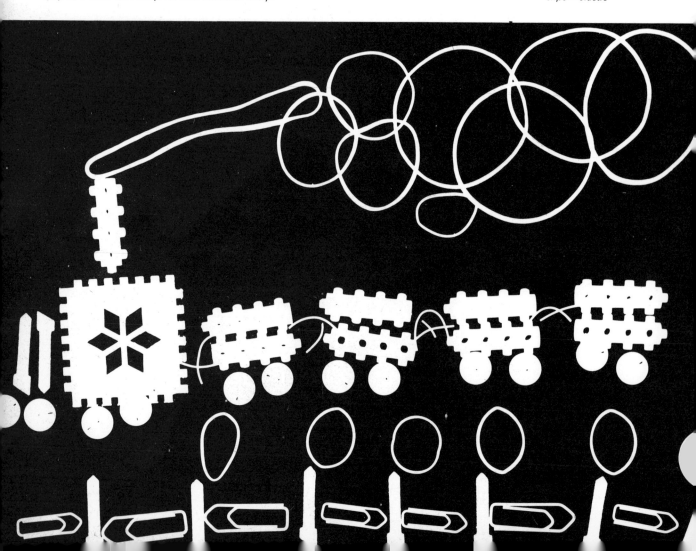

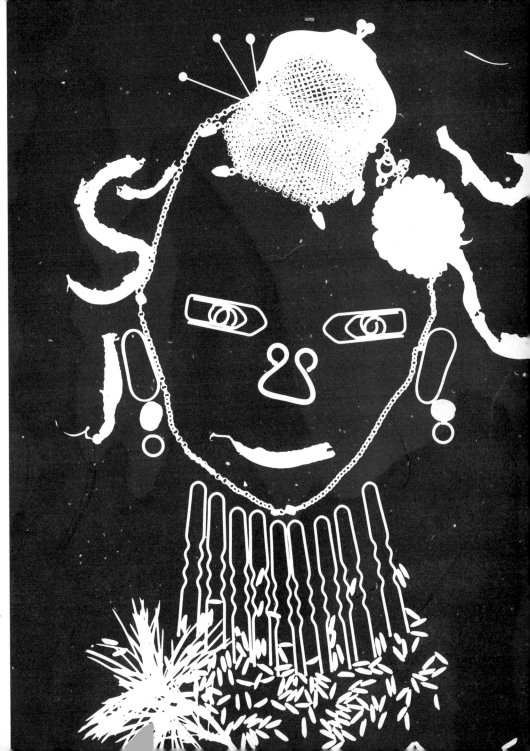

A Chinese face metal—
chain—paper clips—hair
grips—rice

*Effects produced by cutting
and folding*

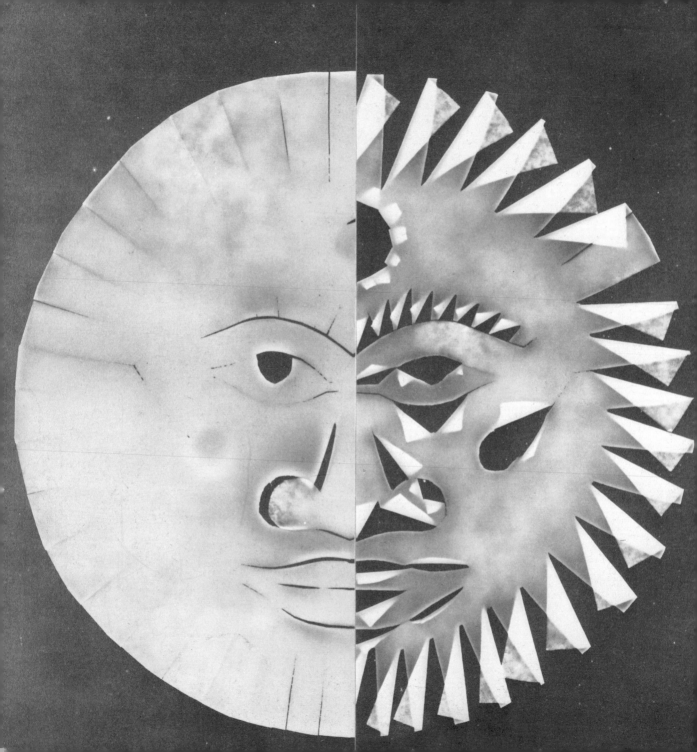

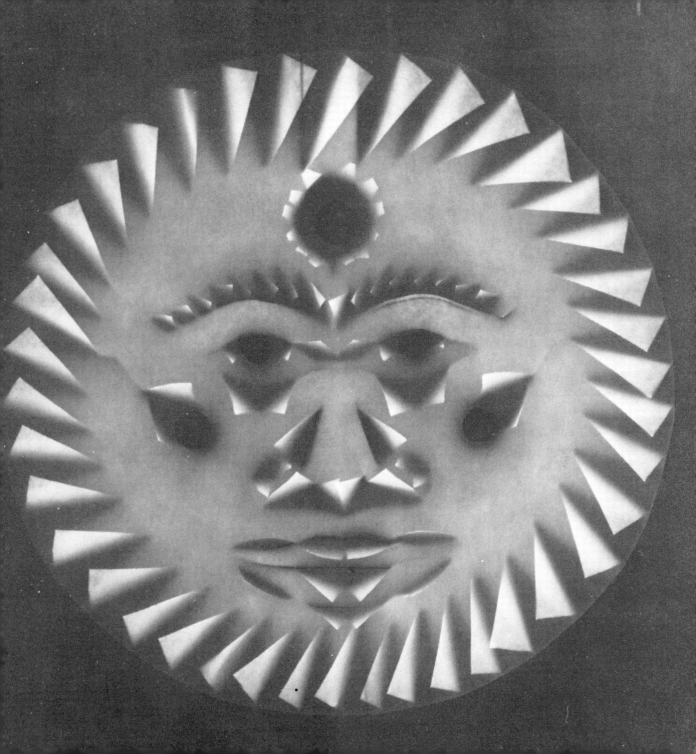

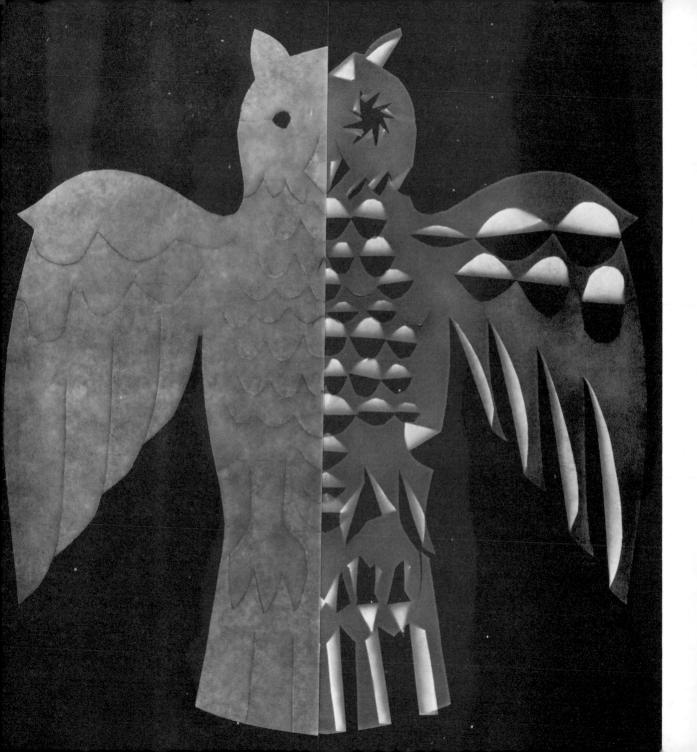

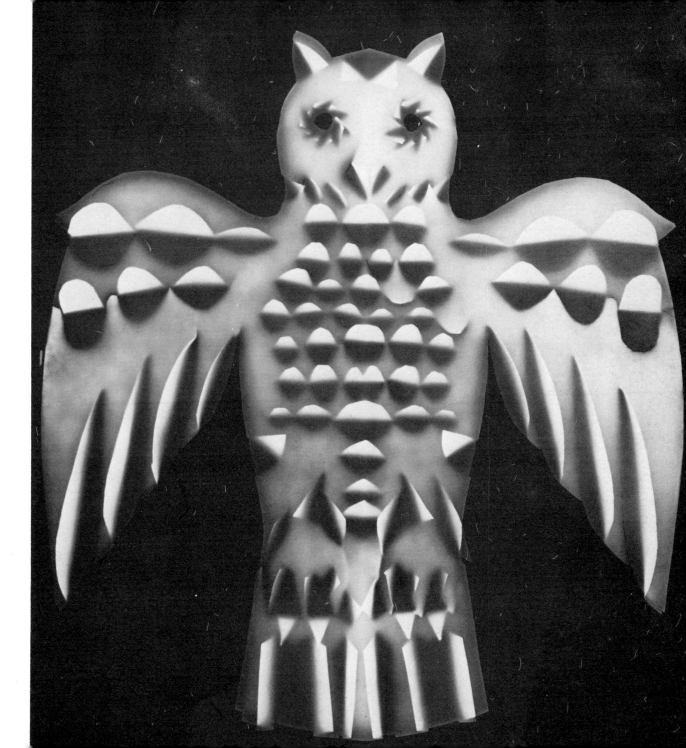

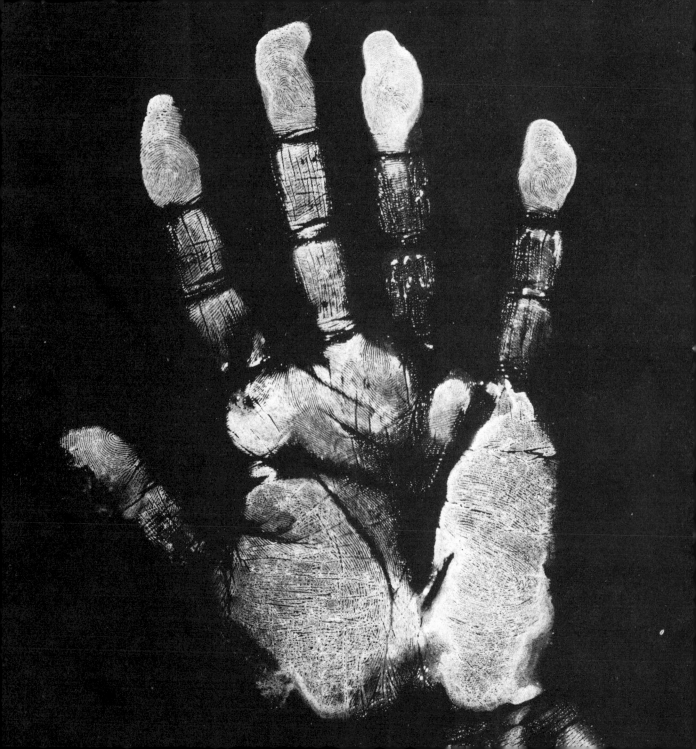

## Hand and foot prints

Soak a piece of thick cloth in fixer, then squeeze out the excess liquid.

Put the cloth on a flat surface. Place a hand or foot onto the light sensitive paper after setting the paper on a firm but pliable base, such as a piece of plastic cloth placed upon two or three layers of pieces of an old blanket.

Expose and develop in the normal way.

The parts of the hand or foot which stand out in relief appear white in the image produced.

Note: The reaction during developing is rapid.

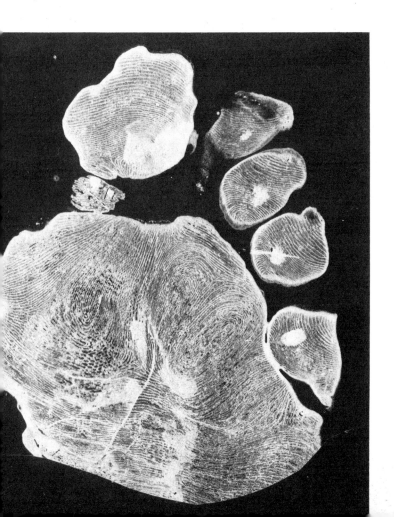

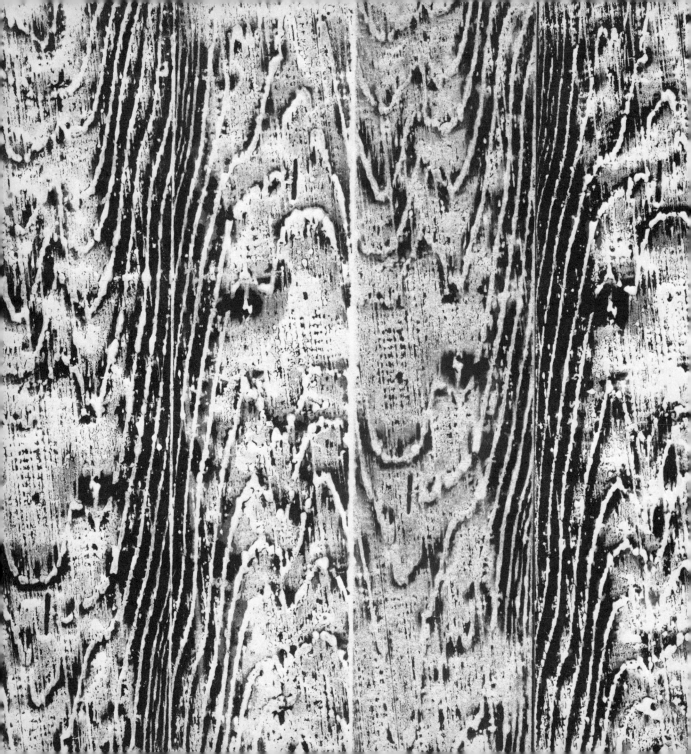

Exercise 32

## Composition with opaque textures

These images are obtained in the same way as the previous prints.

Coat the surface to be reproduced with a thin film of fixer.

Press the surface firmly on the light sensitive paper.

Dry, expose and develop.

Left   *Grain of pine-wood*

Right   *Wax rubbing. The wax acts as a resist to the fixative and causes white bubbles on the image*

Prints from materials are obtained as before.

Press the material into the fixer and dry.

Place the light sensitive paper onto the now light sensitive material, cover with a sheet of glass and press gently but firmly.

Dry the paper, expose and develop.

Left    *Paper towelling*

Right    *Mask on a cloth background*
*Place the paper mask over the material before applying the light sensitive paper*

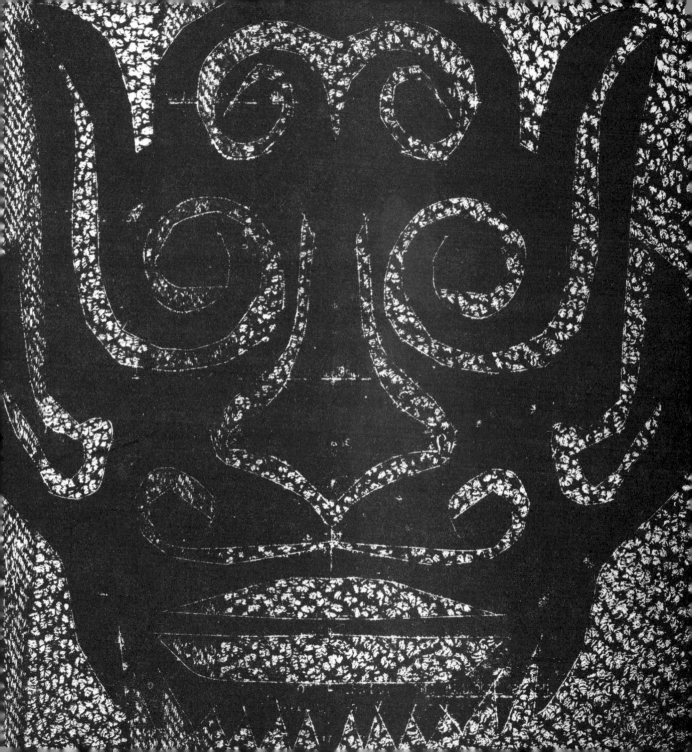

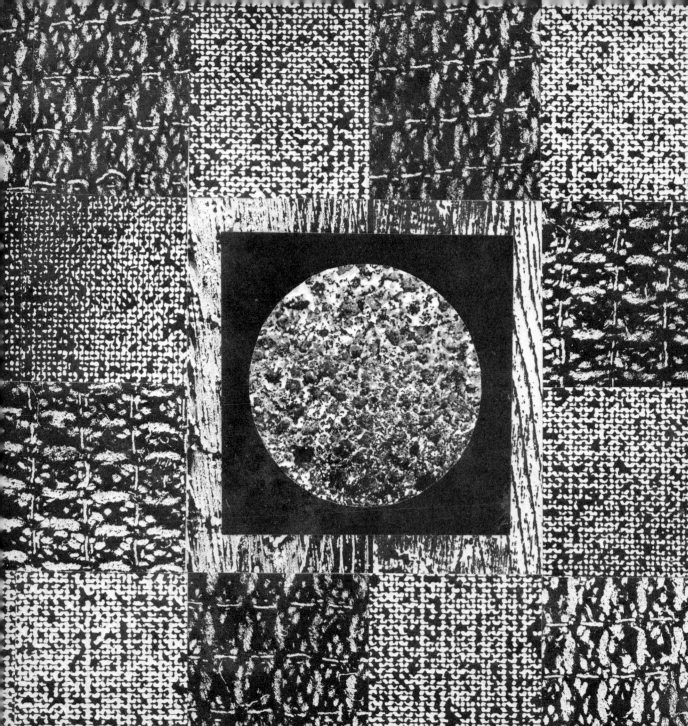

Similar materials such as cloth, sponge and wood can be used to create patterns.

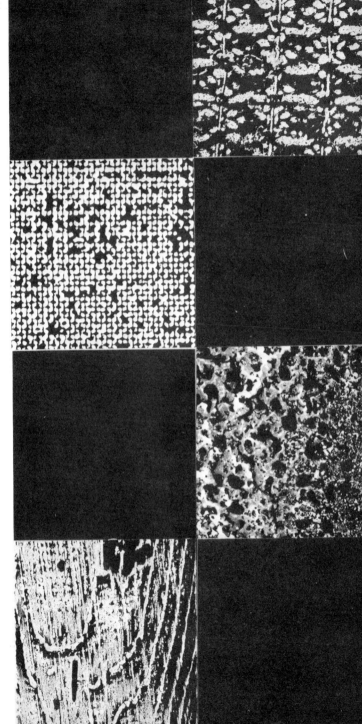

Left    *Design for the lid of a box*

Right   *Chess board*

Exercise 33

## Composition with transparent objects

Patterned glass can be used to create various patterns.

The process involved is the same as that used for normal photograms, placing the different pieces of glass directly onto the light sensitive paper. Different effects can be obtained from the same piece of glass.

Below *Expose for 30 seconds to obtain the background pattern. Then rotate the glass every 5 seconds to obtain the multiple image*

Right *Bird. Composition using pieces of glass. The fir_ variations have been obtained by repositioning the glass an making several short exposures*

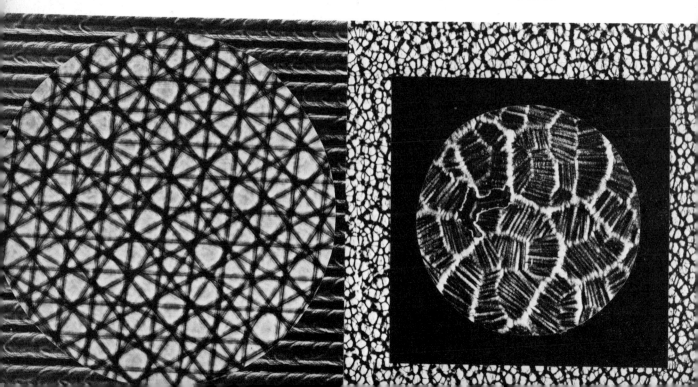

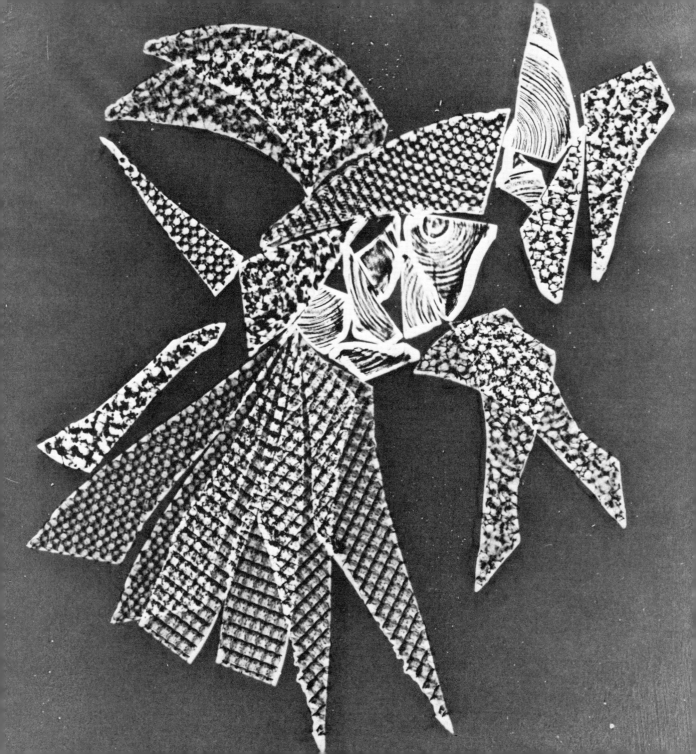

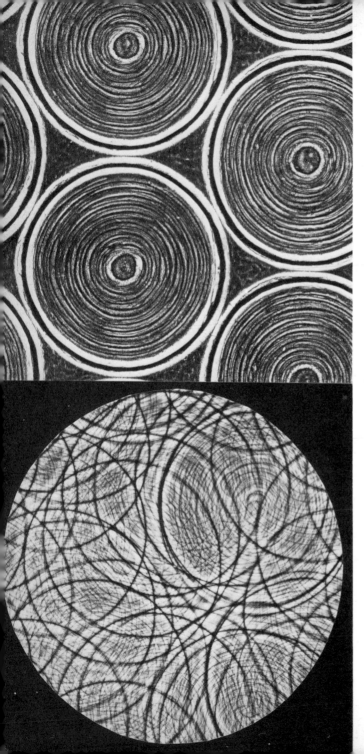

Left (above)    *A glass made up of concentric circles*

(below)    *Images obtained by rotating the glass and making several short exposures*

Right    *The sun. Composition with pieces of glass* ▶

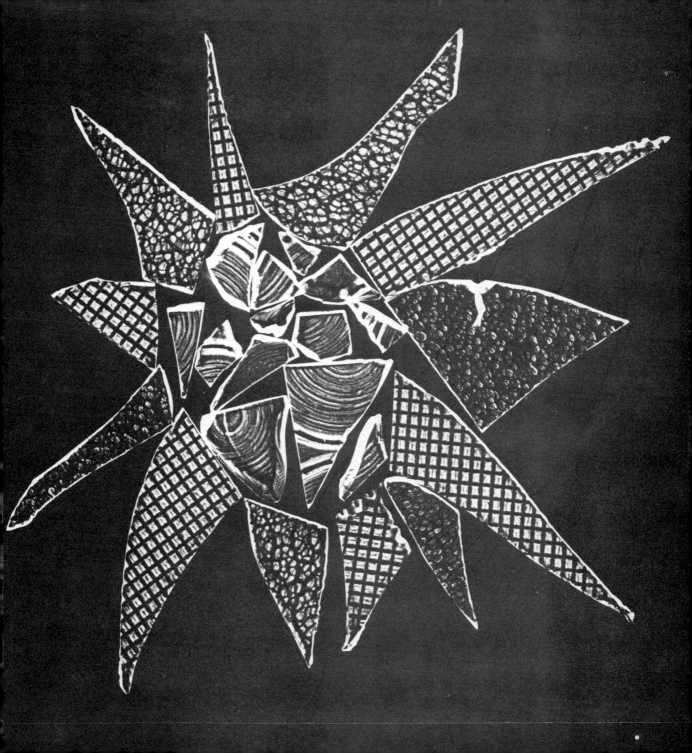

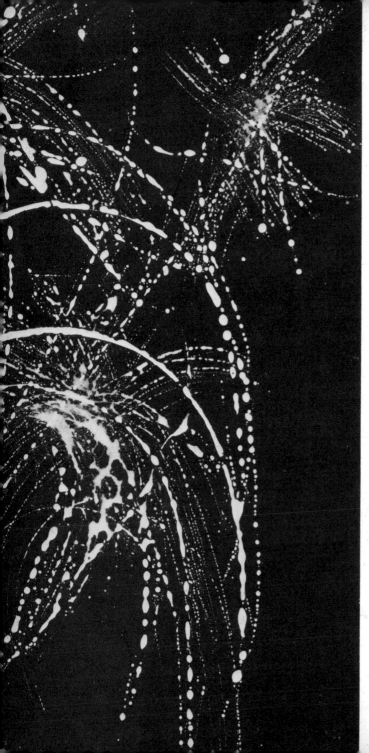

## Splashes of fixer

Apply the fixer with a brush or splash onto the printing paper. Allow it to dry, then expose, develop and fix.

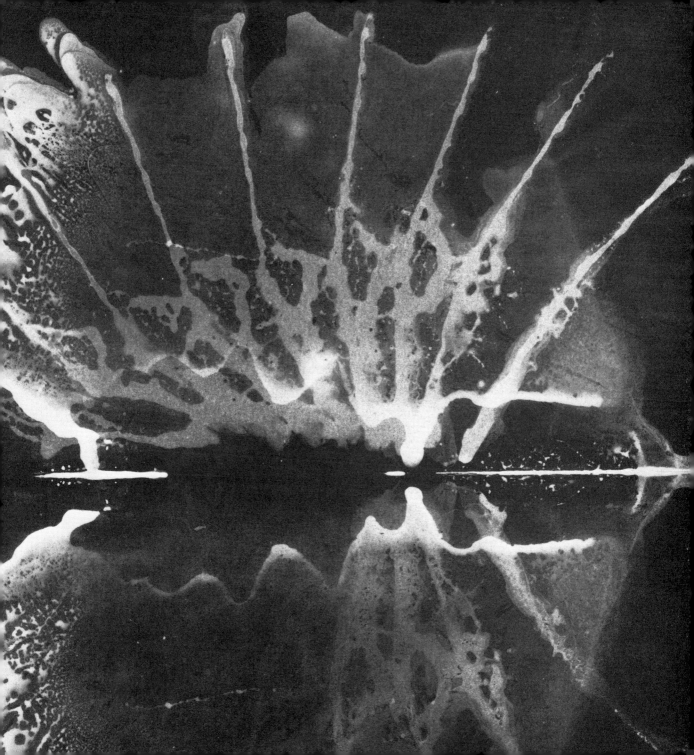

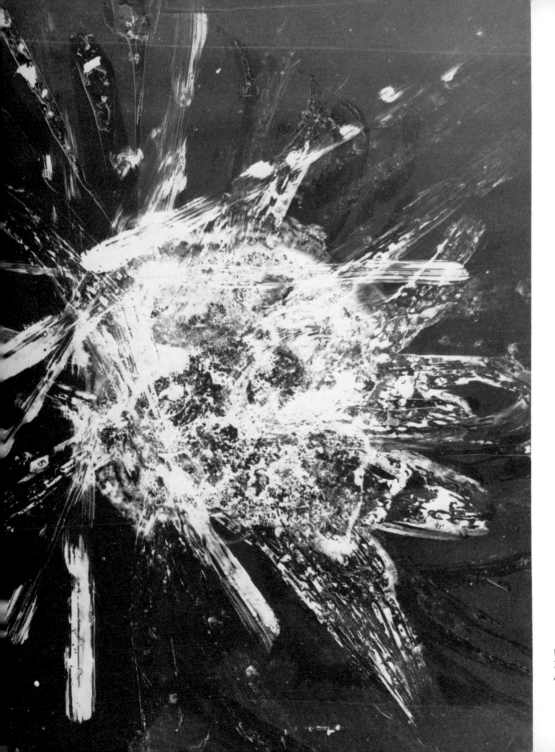

*Water anemone*
*This was made using glue*
*and chinagraph pencil*

Exercise 34

## Photograms and projected transparencies.

The following images have been obtained by means of normal projection onto the printing paper.

Place various substances between the sheets of glass in 35 mm slide mounts.

Pin a piece of white drawing paper on the wall and focus the projected image. Mark its position.

Switch off the projector.

Set up the printing paper in the marked area.

Expose (experiment to determine the length of time).

Develop and fix in the normal way.

(A test strip can be made by covering the printing paper and taking a series of exposures at 3 m (10 ft) distances e.g. 5 seconds, 10 seconds, 15 seconds, 20 seconds, 25 seconds exposures.) (See page 21.)

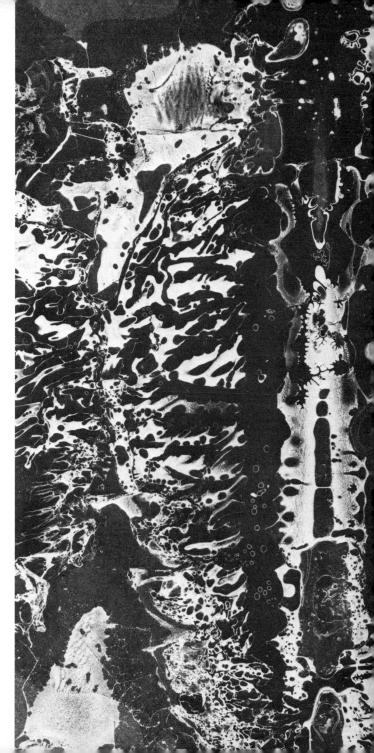

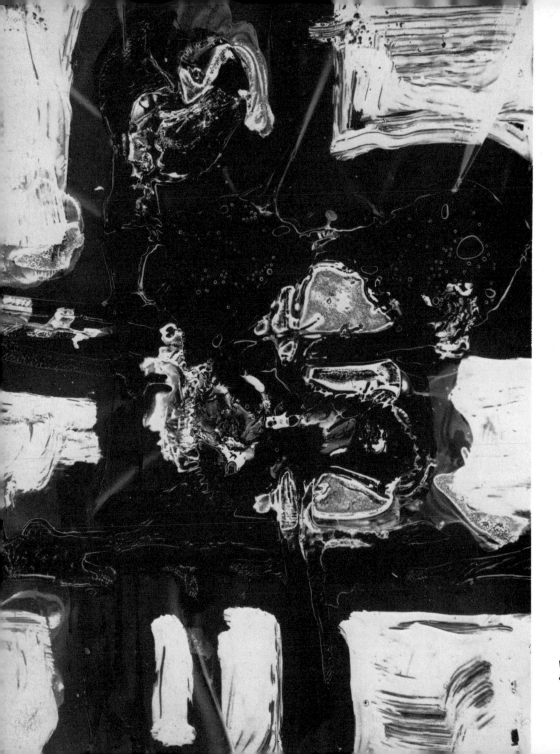

*Virgin and child (glue and chinagraph pencil)*

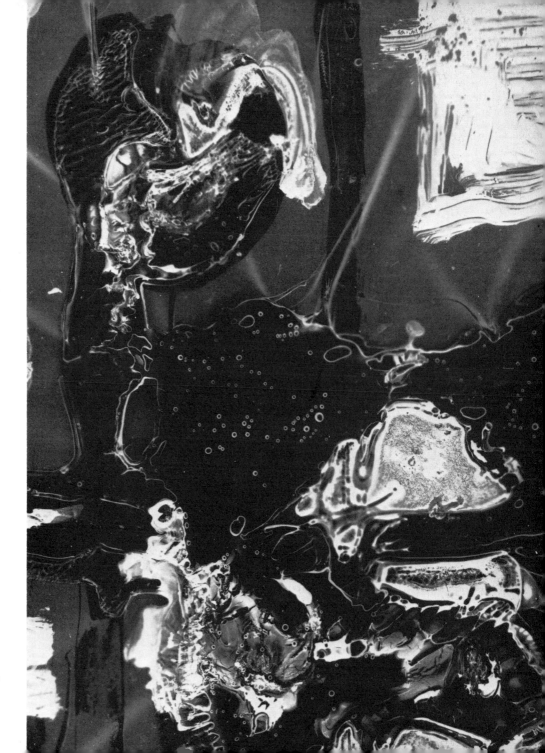

*Virgin and child (detail)*

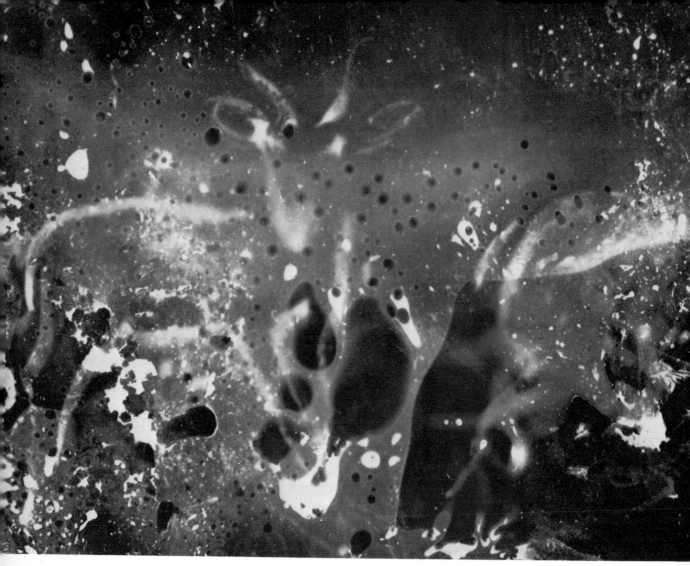

*Composition produced from glue, chinagraph pencil, red felt pen*

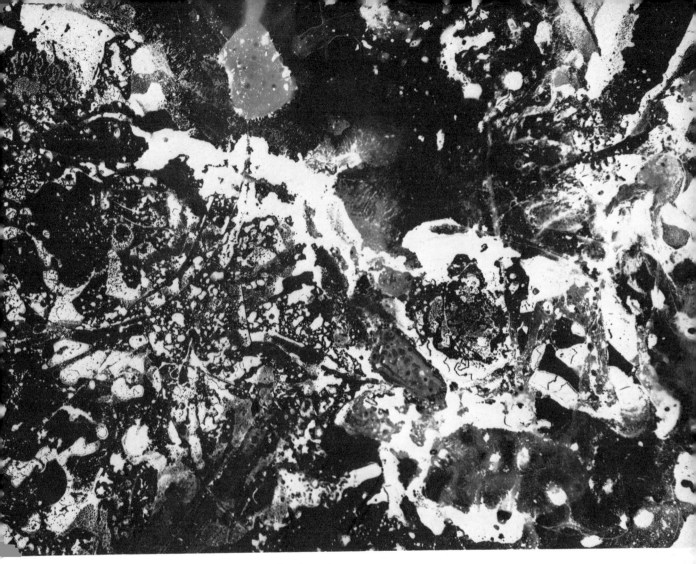

*Composition produced from glue, chinagraph pencil, coloured
thick varnish*

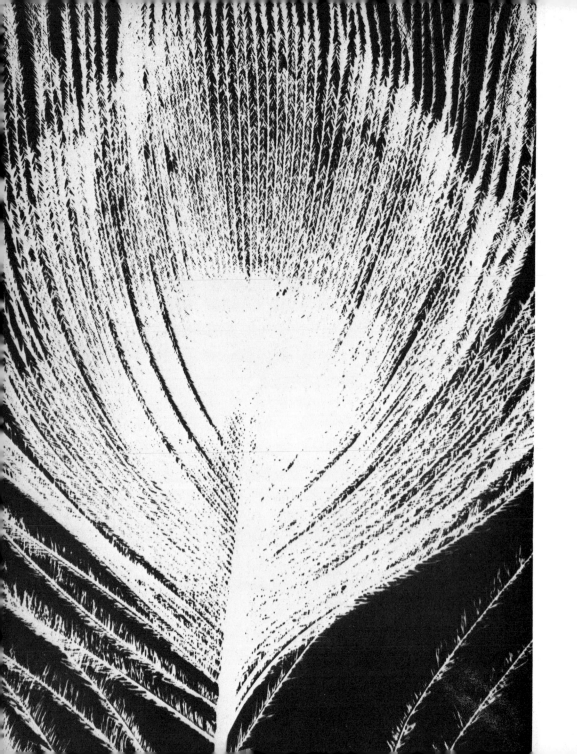

*Peacock feather*

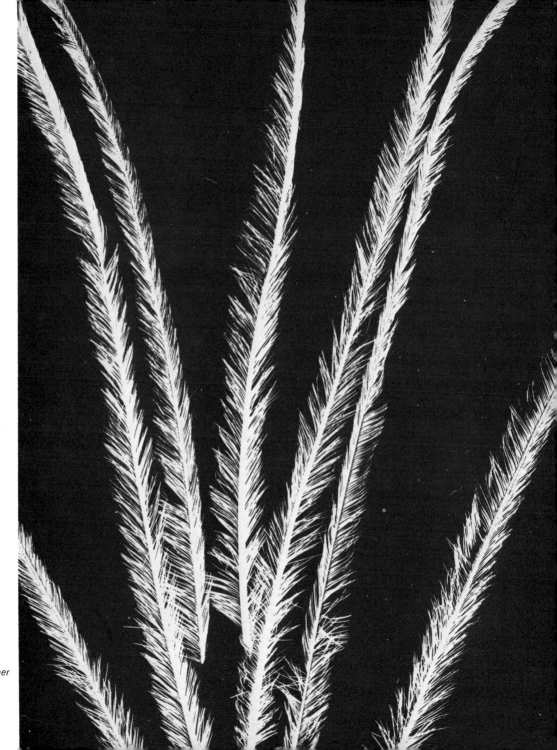

*Enlarged peacock feather*

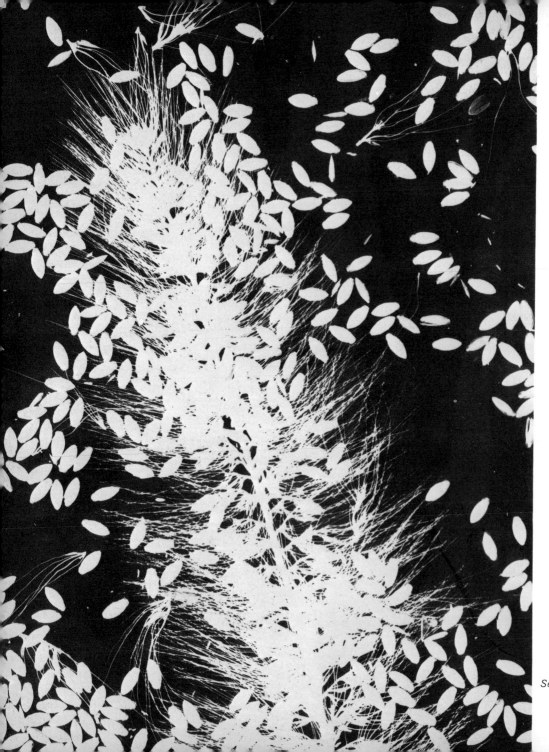

*Seeds blown by the wind*

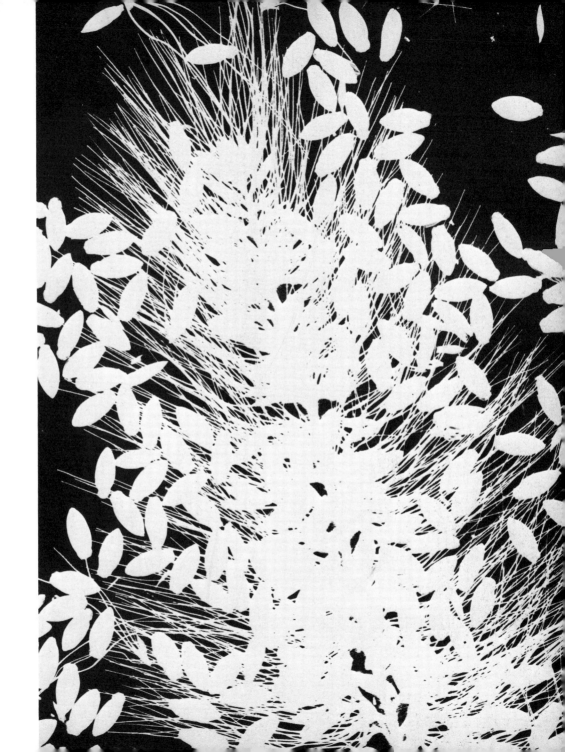

*Enlarged seeds*

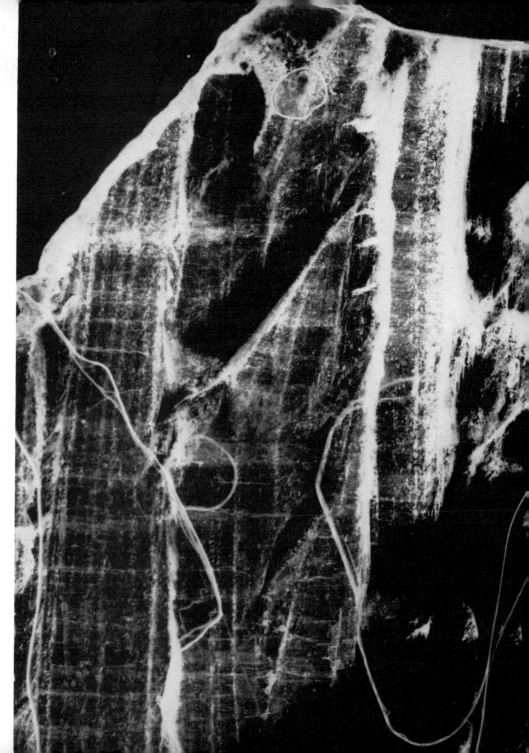

*Scrim*

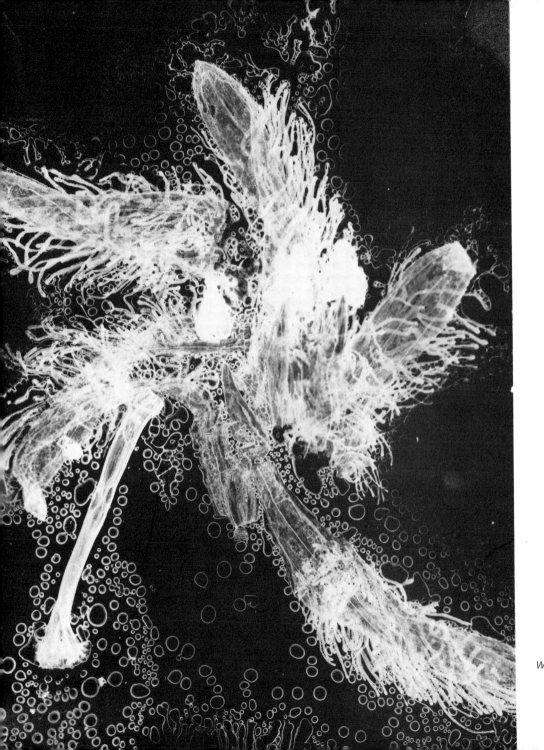

*Water plant in oil*

# MOUNTING PHOTOGRAMS

The choice of adhesive will depend upon what kind of surface the photogram is to be stuck to.

Porous backings: wood, cardboard, cork, plaster, etc require a cellulose-based wallpaper paste prepared accord to the instructions given with it.

The illustrations below show how to approach the task.

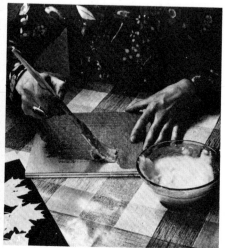

*Apply a coat of paste to the larger surface; in this case the mounting board*

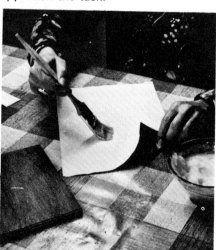

*After the rinsing and drying process the photogram remains damp and while in this state the paste can be applied to the back*

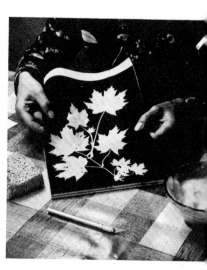

*Place the photogram in position. Smoo out the air bubbles with a damp sponge*

*Paint a coat of paste on the photogram*

*Wipe with a sponge and leave to dry*

*Trim off with a razor blade those part which overlap the mounting surface*

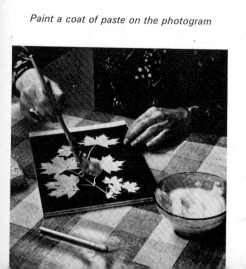

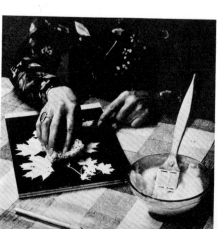

Photograms, like photographs, normally require backing or mounting if they are to be really effective. If they are left unmounted they are almost certain to warp or become distorted.

Mounting surfaces or supports that are impermeable such as plastic, metal or glass require particular treatment.

With these surfaces the photogram must first be completely dried out and then mounted using neoprene based glue. This can be bought in plastic containers which are handy but relatively expensive.

They should be used in accordance with the manufacturer's instructions. Avoid air bubbles and dust which spoil the print.

*Application of heat type adhesive*

For flat surfaces a heat applied adhesive can be used. Coat the back of the photogram with the glue and allow it to dry for 15 minutes. Put the photogram in position and iron with a warm (never hot) iron.

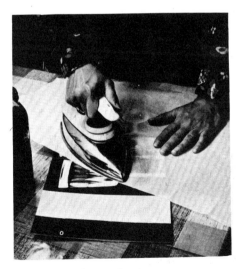

*Ironing on the photogram*

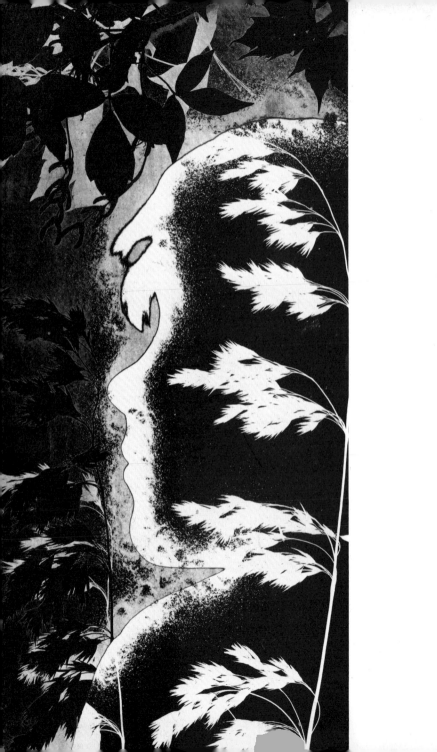

## SUPPLIERS

*For equipment and information:*

Agfa-Gevaert Limited
Sales Department
Great West Road
Brentford
Middlesex

Kodak Limited
P.O. Box 66
Kodak House
Station Road
Hemel Hempstead
Hertfordshire

The Camera Barn, Inc.
1272 Broadway
New York, New York

Willoughby-Peerless Camera Stores, Inc.
12 Waren Street
New York, New York

Equipment is also available from local photographic suppliers including many chemist shops and drug stores.

For American readers additional information of firms dealing with photographic equipment can be found in the Yellow Pages of the telephone directory.